PORTRAITURE UNPLUGGED

Natural Light Photography

Carl Caylor

AMHERST MEDIA, INC. ■ BUFFALO, NY

ACKNOWLEDGMENTS

Thanks to my wife, Theresa, for the title idea for this book. Also, thanks to her and my wonderful children Wyatt and Valerie for giving up time with me so I could work on this project. I love you all more than you know.

I did not get to where I am today without help. There are many fine photographic artists who helped groom me. I especially want to acknowledge a few: Scott Dupras, Darton Drake, Mille Totushek, Donna Swiecichowski, Teri Shevy, Dan Stoller, Fuzzy Duenkel, Randy Peterson, and Jon Allyn. A special thanks to my two photo buddies Dan Frievalt and Michael Mowbray for keeping me company and sane via Facebook while working on this project. We all see things very differently, but in the end, good portraiture is good portraiture.

SPONSORS

Thanks to my sponsors: White House Custom Color (WHCC, www.whcc.com), Kodak Alaris (www.kodak.com), Sweetlight Systems (www.sweetlightsystems.com), and G.W. Moulding (www.gwmoulding.com). Without these folks, live photographic education couldn't exist.

Published by:
Amherst Media, Inc.
P.O. Box 586
Buffalo, N.Y. 14226
Fax: 716-874-4508
www.AmherstMedia.com

Publisher: Craig Alesse
Senior Editor/Production Manager: Michelle Perkins
Editors: Barbara A. Lynch-Johnt, Harvey Goldstein, Beth Alesse
Associate Publisher: Kate Neaverth
Editorial Assistance from: Carey A. Miller, Sally Jarzab, John S. Loder
Business Manager: Adam Richards
Warehouse and Fulfillment Manager: Roger Singo

ISBN-13: 978-1-60895-883-2
Library of Congress Control Number: 2014955672
10 9 8 7 6 5 4 3 2 1

www.facebook.com/AmherstMediaInc
www.youtube.com/c/AmherstMedia
www.twitter.com/AmherstMedia

CONTENTS

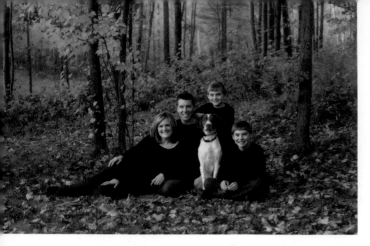

ABOUT THE AUTHOR

Carl is a Kodak Alaris mentor and has been involved with photography for over twenty-five years. He started his photographic career in the darkroom as a custom printer and technician. He is PPA Certified, a Master Photographer, a Craftsman with Professional Photographers of America, and an international photographic judge. He has won numerous national awards for his photography,

including twenty-four PPA Loan Collection images and several Kodak Gallery and Fuji Masterpiece Awards. He has been the Wisconsin State Photographer of the Year three times and has received a multitude of state awards. In 2014, the Wisconsin Professional Photographers awarded Carl the prestigious National Award for his contributions to the field of photography. You can see more of his work on his website: www.photoimagesbycarl.net.

As much as he loves creating portraits, he also has a passion for helping others become better portrait artists. Carl is one of the most sought-after instructors in the country and abroad due to his hands-on coaching approach. Don't plan on just watching in his class! Carl will challenge you to become a better photographer than you already are. His photographic skills are just part of what will help each student. His greatest strength is his ability to see what skills others already possess and then find ways to help enhance those skills so that photographers can take their work to a new level.

PREFACE

This is a book of information, not fluff. When you read through the pages and study the images, you will learn to find and use natural light for your portrait needs. Embrace the ideas. They have worked for many years and will continue to work through the end of time, as natural light portraiture has been around since the beginning of photography.

Our industry has changed rapidly as of late. With all the new lighting equipment on the market, why use natural light? There are several reasons: (1) Biology. The eyes of the subject are more colorful and powerful. (2) Education. The light is constant and can be seen before the image is captured. (3) Cost. Natural light is free. How about that? (4) Subject psychology. The subject doesn't have disturbing flashes going off every time an image is created. (5) Viewer psychology. The scene the viewer sees in an image is natural. I'll elaborate.

First, let's look at the biology. Our eyes are like a lens on a camera. The pupil will expand and contract to let in a comfortable volume of light in a given area. In most cases, we work in open shade, which offers ample light for the human eye. The pupil will contract to a small

> "Our eyes are like a lens on a camera. The pupil will expand and contract to let in a comfortable volume of light in a given area."

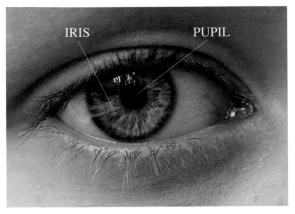

This is a close-up of an eye in a natural light area. Notice all the beautiful color in the iris.

aperture and more of the iris will be visible. The iris, of course, is the colorful part of our eyes. More color means more power. In a dark area, such as a dimly lit studio, the pupil becomes large and covers the iris. If a strobe illuminates the subject at this time, the eye is captured with a large pupil and a lack of color and power. We see catchlights in the eyes of our subjects when viewing an image. If the light source was handled inappropriately or there are several catchlights from different sources, it will be bothersome to the viewer. For you studio strobe folks—if you need to work with strobes and still want power in the eyes, turn on the overhead lights and get a stronger modeling lamp in your strobes. The bottom line is that the constant light needs to be bright enough for the pupil to contract. It's Biology 101.

What about education? When learning the art of placing light on a subject, I feel it is easier with natural light. The light patterns used to sculpt a human face can be seen the entire time

before and during an exposure. There should be no surprises. Once you see the shape, form, and texture of your subject, just record it. We'll get back to this topic later.

Natural light is cost-effective; it's free. No batteries, no wire connections that fail, no cords, no triggering devices, transmitters, receivers . . . you get the point. There are times when we use reflectors or panels to help modify the light, but again, there are no batteries required.

Let's talk about subject psychology. When I first began creating images, I covered sporting events and yearbook assignments. I didn't have a strobe at the time, so I had no choice but to record with natural light. I noticed quickly that my images captured a more true representation of the subject compared to those made using strobe. I noticed that most people acted differently when they knew an image was being taken. With strobe, after one pop, your subject is aware of the camera. Natural light is less intimidating. Even when people are sitting for a portrait, it is human nature to blink when a flash goes off. In fact, many subjects anticipate the flash and blink before it happens. That is not a comfortable situation. In a natural light studio or setting, there are fewer distractions. Natural light allows for a more comfortable scenario, and your subjects look more like themselves.

Next, we come to viewer psychology. When looking at an image, whether we realize it or not, our brain is scanning the image for natural truth. When there is light on a person that couldn't have been there naturally, a little red flag goes up. When there are catchlights from multiple lights that don't make sense, there's another red flag. The more natural and com-

> **"I'm going to show you how to work in this medium so that you can make a living; from there, you can add your own creativity to take your artistry to the next level."**

fortable an image, the more the viewer will like it. Okay, strobes can produce a similar result, but it is more difficult to re-create a "natural" scene electronically. Yes, there are times when it becomes necessary to use strobe, but you need to think about how viewers will perceive the image, not just the exposure. For the purpose of this book, and the understanding that you want to learn natural light portraiture, I will not use the "f" word for our learning examples. "Flash" will only be used to compare the relationship of the strobe studio and the natural light studio. All image samples will show how to use natural light.

Before we move on, I want to mention that this is a book of "bread and butter" portraits done during class demonstrations or for actual clients. In either case, they are always treated with the same respect to artistic ideals. There are a few award-winning images here, but award-winning images don't always pay the bills. I'm going to show you how to work in this medium so that you can make a living; from there, you can add your own creativity to take your artistry to the next level. All I ask is that when you become famous for your work, please contact me and share your ideas so that I may grow as well.

The Basics and Beyond

In recent years, the natural light photographer has been losing credibility. We are seen as hobbyists instead of portrait artists. Part of this is due to the influx of beginners who don't

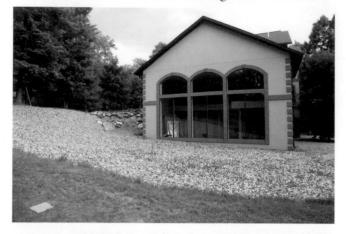

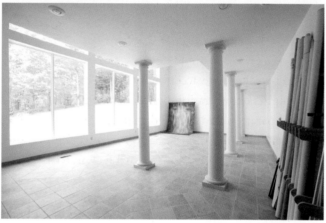

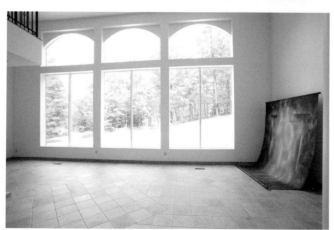

My natural-light camera room.

want to spend money on lights and don't realize there is more to portraiture than just creating a correct exposure of a child running around in a yard. Please don't think I look down on these folks. I started the same way. I hope this book will open everyone's eyes; my aim is to help people grow artistically by learning how to use natural light to produce professional-level portraits.

THE NATURAL LIGHT CAMERA ROOM

I am going to begin with the north light camera room. This is my main indoor studio room. I say this because I use windows and outdoor locations all over the world as my camera room. That's an advantage of natural light. You don't have to carry it with you, it's everywhere.

This room has windows facing directly north. For this reason, direct sunlight will never come into the room. The ceilings are 20 feet high. The tallest part of the glass is 18 feet tall. The height is important. The light needs to move the entire 21 feet across the room to the south and still be just above head level when it gets there. This allows portraits to be created anywhere within the room. The length of the windows combined is 26 feet. Soon I will explain the significance of this length. As you can see, I have a balcony in my camera room. This is part of my home-based business. The upper

"The light needs to move the entire 21 feet across the room to the south and still be just above head level when it gets there."

part of the balcony is attached to the main level of our home and is used as a workout area and lounge. I can also use it to photograph from directly above my subjects, and it has come in handy for seniors and commercial work throughout the years. The balcony is supported by pillars designed to be a permanent, classical set in my studio. The floor is Italian porcelain in neutral colors with design work that can also be used in portraits. Outside the windows is a cleared area with light decorative rock. This helps with color issues later in the day when the sun is on the ground outside the windows. One more important note: There is a wall on either side of the window. My walls are 4 feet long. If I had it to do over, they would be 12 feet long. The walls allows you to control the density and focus of your background while your subject remains in good light. No matter where you go, indoors or out, look for a lighting scenario such as this: a ceiling to block light from above, light allowed in from one direction, and an area of controllable backgrounds.

STROBE/NATURAL LIGHT CORRELATION

I use these windows as I would use strobes. As you can see in the diagram, the principles of lighting a person are the same in each approach. A light should be placed at about a 45 degree angle from the subject on a horizontal plane and about a 45 degree angle on a vertical plane. This "main light" produces directional light that will create shape and form on the subject. The main light should be evident in the subject's eyes as a catchlight (a white highlight in the eye). The catchlight should be at about 2 o'clock or 10 o'clock in the iris, depending on what side of the subject the main light is placed. A fill light can be used to bring the relationship

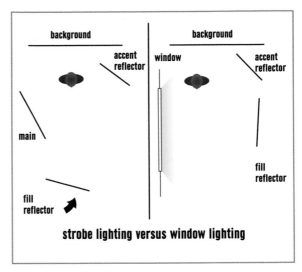

Studio-window diagram.

of the shadow and the main light to a desired, printable unity. Remember, the main light gives direction. The fill light shouldn't alter that direction. We'll talk about that in greater detail soon. Then there are accent lights (also called kicker lights or separation lights). These lights create separation and are used to keep the subject from blending into the background. They also help create a three-dimensional feeling to the flat piece of paper we call a picture.

As you'll notice, these light sources do not point directly at the subject. They skim the subject. Yes, not only do we want a direction of light that gives us shape and form, we also want texture on the subject. The only thing in nature that will create texture is light skimming across a surface. A good example: If you want to photograph ripples in the sand on the beach, when do you go? Sunset or sunrise of course—but you will get the most out of the scene right when the sun disappears over the horizon. This is when there will be a direction that shows the crests and valleys of the ripples, and also the grains of sand within the scene. The human

face is a reflective sphere. Within that sphere are other shapes: eyes, nose, cheekbones, hair, and pores in the skin. As an artist, I want it all to be seen. So no, it's not as easy as pointing a light at someone and recording the image. There is so much more to it than that. I'll get to the use of light in a moment, but first we need to talk about the physics of light.

Light will always travel in a straight line. For the sake of understanding, let's just assume the light from a given light source is a beam of light. In the beam itself, the center is most concentrated and intense. Anytime the beam travels directly at a reflective surface, such as the human face, the surface will reflect that beam directly back at its origin. This will cause a spectral highlight (a white reflection with no detail). This is why we use the edge of our light source. It keeps us from losing detail in our subjects.

You will find that there are small light sources and large light sources. Each produces a different effect. A large light source is one that is large in relationship to the subject. An 8-foot window facing north with a subject 2 feet away is a large light source. A 2x2-foot window 10 feet away is a small light source. An open sky on the shadow side of a building is a large light source. The sun in an open field at midday is a small light source. A small light source will produce very defined shadows and a great deal of contrast. A large light source will create soft-edged shadows and more natural fill from highlight to shadow. Both can be used in a natural light portrait, but I tend to favor the larger light sources or at least small light sources without direct sunlight. Most people I photograph can't keep their eyes open in direct sunlight. So unless my subjects are wearing sunglasses, I stick to working in open shade.

"A large light source will create soft-edged shadows and more natural fill from highlight to shadow."

Light will always fall off in intensity as it travels farther from its source. (This principle is known as the inverse square law.) I will avoid being overly technical, but you should note that the farther the light travels, the less there is to expose an image. It is this principle that will explain the use of different-sized light sources. I'll start with a small window. If the subject sits on the edge of the window, the light from the window will show on the person's face. The light may only show on one side of the face. This is because the face itself blocks the light from hitting the other side. If the subject sits on the edge of a large window, the face is still in good light, but the light traveling from the opposite side of the window can also reach the opposite side of the face. This is what we call wraparound light. Because light falls off (at a rate described by the inverse square law), the light traveling from the opposite edge of the window from the subject is less intense than that on the highlight side of the face. This is an important principle to understand, as it will dictate how you will use any given light source.

What Is the Inverse Square Law?

The inverse square law for light intensity states: "The intensity of light is proportional to the inverse square of the distance from the light source."

For those of you who do not like math, just understand that the farther your subject is from the light source, the less light there will be on your subject.

Most of us would guess that twice the distance from a light source would cut the intensity in half. That is not the case. Doubling the distance would change the intensity by the square of one half; in other words, we would end up with one fourth the intensity. If you move the source or subject three times the distance, the intensity would change by the square of one third, or one ninth the intensity.

The closer the subject is to the light source, the greater the change in intensity with a small distance change. In other words, if you stand one foot away from a light and take a reading, then move back one step, there will be a greater change compared to if you were twenty-five feet away and took one more step back. This is good information to know for group portraits. If you have three rows of people and want the light to be the same intensity on all rows, move your light as far away from them as you can while still achieving the exposure output required to use the aperture needed to carry the focus throughout all three rows. In contrast, if you place a light very close to the subjects, the person in the front row may be much brighter than the person in the back row.

There are some exceptions. You can use the inverse square law to predict the rate of light falloff for speedlights and studio strobes. Umbrellas and small softboxes will follow the law quite closely for distances greater than twice their diameter, but there are some exceptions. Light sources modified by focusing units (like a fresnel lens) or those outfitted with a grid will not follow the inverse square law as predictably. Also large, diffused light sources like a north light wall of windows will fail to follow the same equation. That said, still, the farther away the light source is from the subject, the less intense the light will be. The wider the window, the larger the working portrait area.

"You can use the inverse square law to predict the rate of light falloff for speedlights and studio strobes."

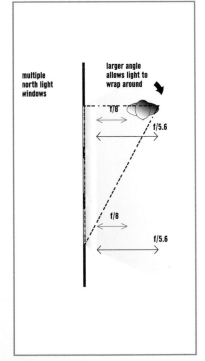

multiple north light windows

larger angle allows light to wrap around

f/8
f/5.6

f/8
f/5.6

north light windows

f/8 f/2.0
f/5.6

Large light source.

Small light source.

TOOLS OF THE TRADE

Reflectors are very important tools for working in natural light. I use several, ranging from white to very bright, mirror-like silver materials. I do not use gold. Reflectors are used to add accent light or to fill (lighten) shadows. Shadows are cool in color temperature. Gold is a very warm color temperature. The two do not mix well. The only exception to this is on a pastel sandy beach at sunset. When everything seems to have a warm glow to it, a gold reflector can be of some use.

The reflectors I use come from a company that is no longer in business. In the future, check out Sweetlight Systems at www.sweet lightsystems.com. They create light modifiers and are looking to get into the reflector business as well. I have also used, and still do at times, insulation board (available at building supply stores). It works just fine, though it doesn't look as nice and takes up more room when traveling. I like a reflector with a "kickstand" so that I don't need assistants. The reflector with a kickstand also works fine as an under-reflector outdoors. I like to have two reflectors along on an outdoor session if I can. At least one should have black covering one side. This way, I have a reflector and a gobo with me at all times. When I'm inside, I use a bright silver reflector for accent light, a soft silver reflector for fill, a small reflector on a goose-neck stand for an under-reflector, and a gobo on a goose-neck stand as shown in the images on the facing page.

A good tripod is an essential piece of equipment. I use a Bogen Manfrotto #058B tripod. It is a heavy but very effective tool. The length of the legs are controlled by levers up where you hang on to the tripod itself. By pressing the middle levers, all the legs are loosened and mold to even the toughest terrain. When you release the lever, the legs lock. You can also adjust each leg individually with the smaller levers as shown in the close-up image (facing page). No more missing the image because you're messing with tripod legs. This is one thing I cannot live without.

I do not care for camera straps. They pull on your neck and shoulders and they allow your

LEFT ▼ Indoor bright and soft silver reflectors. The bright silver is used for accent lighting. The soft silver is used for fill. Both stand alone without assistants.

RIGHT ▼ Black back for subtractive light. At least one reflector I carry will be black on one side. This way, I always have a gobo along with me to block light where I don't want it.

TOP LEFT ▶ Outdoor large reflector. This is a more durable reflector for use in tougher environments. It comes apart and rolls up for easy traveling. It has a self-supporting stand.

BOTTOM LEFT ▶ Under-reflector. This is a great tool for use in the studio. It is used on the highlight side of the subject and from underneath. It is faced toward the window and feathered back to the subject until you just begin to see the catchlight in the eyes. Be careful! This is the most overused light source in natural light portraiture.

RIGHT ▶ Gobo. This is a black panel on a gooseneck stand. Use it to keep light off small areas where you do not want it. It's like custom burning in-camera!

LEFT AND ABOVE ◀ ▲ Tripod and tripod close-up. The Bogen Manfrotto #058B with a ball-joint head. This tripod allows the legs to be adjusted with gravity. By pressing the red levers shown in the photos, the legs fall down until they rest on solid ground. There's no need to reach down to unscrew each leg section. This model allows you to work quickly over even the roughest terrain.

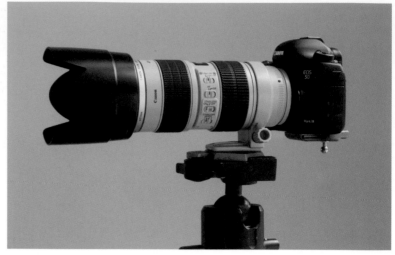

LEFT ▲ Spider holster (www.spiderholster.com). This is my preferred replacement to the neck strap. It is comfortable and safe for your camera and your subject. It does not allow your camera to swing at them when you lean over to fix their hair or clothing.
RIGHT ▲ Canon 5D Mark III with Canon EF 70–200mm f/2.8L IS USM lens. This is my go-to choice for natural light portraiture.

camera to become a wrecking ball each time you bend over to fix hair or clothing on a guest. I prefer the Spider Holster (www.spiderholster .com). This belt and holding device solves all issues and can lock the camera into place. I have ran and jumped over rocks with my camera in this holster. It's great to have a safe place to store your camera while you are setting up a shot.

Last of all, there is the recording device. Why is it the last tool I listed? Because it is only that— a tool, a recording device. Working with the relationship of the subject, the light, and the background is creating photography. I can record it on my iPhone or my Canon. Yes, my Canon 5D Mark III is something they will need to pry from my cold, dead hands someday, but it doesn't create anything. It just records what I do. That being said, it is a fine piece of equipment. It allows me to work at high ISO settings for my portraits and gives me what I expect each time I press the shutter release button. I use several lenses, but my workhorse is the Canon EF 70–200mm f/2.8L IS USM lens. You will see more of my lens selections later in this book.

UNDERSTANDING EXPOSURE, MANUAL STYLE

Next on the agenda is how to create the correct exposure. This is a camera thing. When you were just learning to take pictures, you probably set your camera to auto or program mode and let it do all of the work. For full artistic control, you'll need to set your camera to manual mode. Ask yourself questions about the scene. For instance, do you want a lot in focus or just a small area? Do you need to stop the movement of a child running across the yard? The answers to these questions will determine your exposure-setting selections.

Of course, getting a proper exposure is critical. Therefore, let's start our discussion with metering. There are two ways to meter your scene: you can use a reflective meter or an incident meter. The meter in your camera gives you a reflective reading. A hand-held meter will give you an incident reading or, when fitted with

an attachment, a reflective reading. The reflective meter measures the light bouncing off the subject. An incident reading tells you how much light is present at the subject. Both will work with practice.

The meter in your camera is a reflective meter. It should tell you whether your shutter speed and aperture settings harmonize to give a correct exposure for any given scenario. To use this meter, you simply look through your viewfinder and watch the meter readout. You can adjust the aperture (f-stop) or shutter speed until the exposure needle appears in the center of the graph. Of course, you must be pointing the camera at the specific area of your scene that you want to expose for. In portraiture, that would be the highlight side of the subject's face. Yes. Expose for the highlights. If your highlight is overexposed, there is no visual information (detail) there. You need to expose your highlights properly. *Note:* Not all light meters are calibrated correctly. You need to test your equipment. Your meter may need to be calibrated to a known, correct reading. In the end, you should be confident that your meter, hand-held or in-camera, will give you an accurate reading. If you are using a hand-held (incident) meter, position the meter on the highlight side of the subject's face and point the meter's dome at the light source. Entire books could be written on exposure. For the purposes of this book, let me finish by advising you to practice!

There isn't enough space in this book to get too deep into f-stops and shutter speeds, but I will touch on those topics.

The light meter. This is a hand-held light meter. It is used to measure the ambient light falling on the subject. Notice the dome points toward the light source. There are also attachments to use this meter for a reflective reading, just like the meter in your camera.

Let's imagine that a meter reading of a hypothetical scene yields recommended camera settings of $1/125$ second at f/8 (at ISO 400). This will create a correct exposure. However, other settings (called equivalent exposures) will allow for the same correct exposure. Why would you use different exposure settings? Well, in some scenarios, you'll want to use a wide-open aperture to blur the background and eliminate distractions. In others, you'll want to show the beauty of the natural environment, and you'll want the background sharp. When you change the aperture, you reduce or increase the amount of light used to record the image. You'll need to reduce or increase the shutter speed to maintain the correct exposure. There are times when stopping the motion of a running child will require a fast shutter speed. You may need a faster

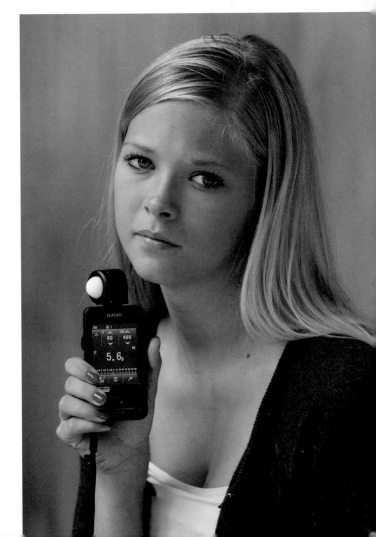

shutter speed if you are working with a heavy lens, as well, to prevent blur from camera shake.

Now, let's assume that your meter gives you a reading of $1/125$ second at f/8. This setting might help you prevent motion blur that stems from an unsteady hand. F/8 offers a great depth of field. (*Note:* Depth of field is the amount of the scene that appears in focus on a horizontal plane from the camera.) That aperture setting may well keep the distracting background elements of the scene in focus. Looking at the chart below, you might consider changing your exposure to $1/500$ second at f/4 so the background is less in focus.

A third control used to adjust exposures is the ISO. The ISO governs the light-sensitivity of the sensor. A high ISO, say 1600, makes the camera more sensitive to light. A low ISO setting, say ISO 100, reduces the sensitivity of the sensor. A low setting is a good choice for very bright, sunny scenes.

ISO 400 is my go-to setting for natural light work. It used to be true that you'd see more noise in an image shot at ISO 400 than ISO 100, but with today's sensors, there is no real difference in quality. You may as well take advantage of using a higher ISO so that you can choose a faster shutter speed to stop motion. The ISO performance in newer cameras is impressive. I have no problem working at 3200 ISO on my Canon 5D Mark III camera. Yes, there is a difference in noise, but it isn't objectionable, even for the most critical of eyes. I have even used settings beyond 3200. Noise is present in extreme ISO settings, but it's not as noticeable as the grain we saw in high ISO films. If you need the exposure and the light is lacking, don't be afraid to use even the highest ISO setting your camera offers.

LENSES

I mentioned that I use the Canon EF 70–200mm f/2.8L IS USM for most of my work. I favor the narrow angle of view that the lens allows. This allows me to find small background areas without hot spots and distractions. It also compresses the background and helps eliminate distractions.

There are times when a wide-angle lens is the right tool for the job. You will know it when it comes up. A family grouping or a wedding party is not one of those times. A wide-angle lens will distort and create unflattering size relationships as subjects are placed behind one another. The subject in the front row will have a large head, while the guy in the back will have a tiny face. Don't be a witch doctor. I recently bought the Canon EF 85mm f/1.2L II USM lens. I love it! One last tip: Use the lens hood that came with

		ISO 400	ISO 800
stop action	f/1.4	$1/4000$	$1/8000$
	f/2.0	$1/2000$	$1/4000$
	f/2.8	$1/1000$	$1/2000$
	f/4.0	$1/500$	$1/1000$
	f/5.6	$1/250$	$1/500$
	f/8	$1/125$	$1/250$
more in focus	f/11	$1/60$	$1/125$
	f/16	$1/30$	$1/60$
	f/22	$1/15$	$1/30$
	f/32	$1/8$	$1/15$

Exposure equivalent chart. Once a correct exposure is calculated for a given scene, many options are available as long as you are working in the manual camera mode. This table shows all the aperture and shutter speed combinations that will work in this area and still produce a correct exposure. Some will allow for stopping action while others will allow more depth of field.

your lens. You have a big expensive piece of glass in your hands. The hood helps protect it and prevents lens flare. If you want flare, take it off to get the shot, then immediately replace it and continue shooting. You'll be amazed at the difference in clarity you will see in your work by using the lens hood.

WHITE BALANCE

In natural light photography, it is very import-ant to understand white balance. The color temperature of the light may be different in any given scene. When shooting outdoors, I typical-ly work in open shade. When I'm in those areas, setting my camera to the shade white balance preset works fine. But there are times when the light changes—a cloud moves overhead, a red car parks where it reflects light in your direc-tion, or raw light bounces off a yellow build-ing. All these areas need to be custom white balanced. The same goes when you're working with window light. Glass has a colored tint to it; our eyes don't see it, but the camera does. By doing a custom white balance, the color balance in that area becomes correct for your recording and your subjects are rendered the right color.

The first step is to meter the scene. If you don't have the correct exposure, you cannot achieve a correct custom white balance. To be consistent, I record an image of a special gray card. You need to fill the frame with this card. If you can't focus that close, don't worry. The card doesn't need to be in focus. Once the gray card is recorded, check your math (i..e., dou-ble check that your exposure was correct). You can do this by looking at your histogram. The

TOP ▲ Histogram.
BOTTOM LEFT ▲ Before custom white balance.
BOTTOM RIGHT ▲ After custom white balance.

histogram is a graphical representation of all of the tones in your frame. When you photograph a gray card, the histogram should look like the graph shown here. The middle spike represents the gray center of the card. The spike on the left and right represent the black and white areas re-spectively. Notice the spike in the center is wider than the outsides. This is because the histogram

shows the percentage of that assumed density throughout the frame. There is more gray, so that spike is wider. Once I see this correct graph, I flip the gray card over to white, fill the frame, and record it. Do not change the exposure! You must do this in manual mode or lock your exposure from the gray card. In your first image, the card may appear off-color. Next, go into your camera's menu, find the custom white balance option, and select it. Your camera will ask you if you want to use the last image. Yes, you do. Your card should now appear white. Your camera will now tell you to choose the custom white balance (if you weren't already set on it). Record an image of the person holding the card just to be sure the colors look right. You are now ready to create images until the next cloud moves overhead.

REFLECTOR PLACEMENT

Reflectors are light sources, just like windows or strobe lights. The placement of these light sources is critical. A light shouldn't be pointed directly at our subjects. Rather, the edge of the light should be used. The same is true of a reflector. I place my accent reflector first; it is positioned behind and to the shadow side of the subject. As you can see in the images on this page, if a line was drawn perpendicular from the reflector surface, the very edge of the light source would skim across the subject.

The fill light reflector is placed in a similar fashion but in front of the subject, as shown. In my studio, it actually points directly at the windows. Do not angle this reflector toward the subject. If you do, you will see a cross shadow under the nose, which is not flattering. Remember, fill light shouldn't change the direction of the main light. It should just fill the shadow area.

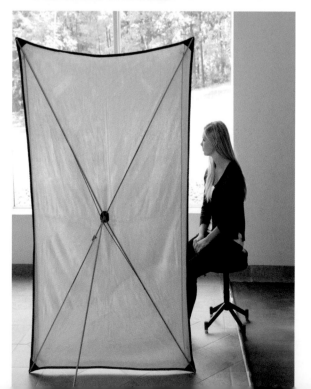

TOP ◄ The accent reflector is placed behind the subject with just the edge skimming light across her outline. It is usually on the shadow side, but on occasion, can also work from the highlight side.
BOTTOM ◄ The fill reflector is placed across from the main light in front of the subject. It is used to control the intensity of the shadow in an image without changing the direction of the main light.

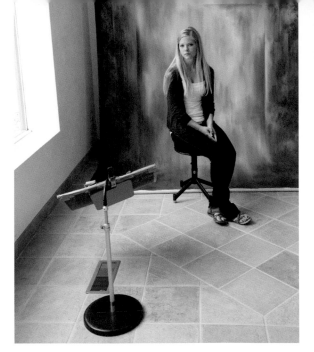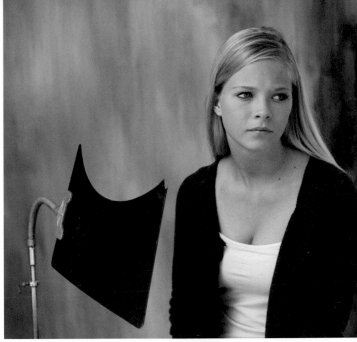

LEFT ▲ Under-reflector placement. The reflector from underneath the subject actually stays on the window side of the subject and tilts toward the window. Feather it back to the subject until it shows in the eyes. Be careful. This reflector destroys more images than any other light source. Again, it should just add a little light in the eye and under the chin, but not change the direction of the main light. **RIGHT** ▲ Use a gobo to block light from falling on areas you don't want lit. The gobo is your "in-camera burn tool"; darken areas now, then there will be no need to take care of problems later.

The under-reflector is an often misused tool. It is used to put a little light in the eyes, under the chin, and in the eye sockets. It should not change or compromise the main light direction. This reflector should point back toward the window and is placed on the *highlight* side of the subject (see the image above). To determine the best-possible placement, start by pointing the reflector at the window. Slowly tilt the reflector toward the subject until you see the light in their eyes. Stop there! Don't overdo this. When it's overdone, light will shoot up the nose. I call this "cocaine lighting." Just say no.

You will sometimes hear photographers talk about subtractive lighting. Some think this is the practice of using a black panel or fabric on the shadow side of the face to suck light from the subject. Well, light cannot be sucked away. All the black panel does is keep light from coming from that direction—just as the subject's own face blocks light from hitting the far side of the face when you are using a small window. The tool used for subtractive lighting is called a gobo. A gobo can be used to block light from the entire subject or just parts of the subject. In the image above, a gobo was used to block light from striking the subject's chest. A gobo is used in every image in one way or another. In the camera room, my ceiling is a gobo. The walls are gobos. You get the idea.

PORTRAIT LIGHT PATTERNS

There are many specific light patterns that have been used in master paintings as well as photographic portraits for centuries. These patterns are appealing to viewers and help tell a story of the subject at the moment the image was captured. These patterns are proven to be

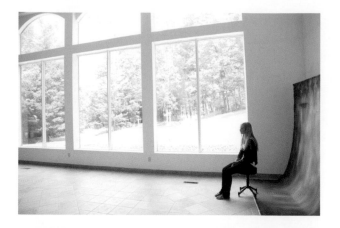

TOP LEFT ◄ Use the edge of your light source. In my studio, placing the subject on the edge of the length of windows produces better wraparound light and better texture on the subject. It also keeps the light direction coming from the side and the front of the subject, rather than from both the front and back.

BOTTOM LEFT ◄ This image shows the short light pattern. The mask of the face is lit. A fill reflector was used to lighten the shadows, narrowing the tonal range from highlights to shadows.

BELOW ▼ This is the same short light pattern, but with no fill reflector. Notice how the shadow is a bit darker than before.

flattering. Try to use them. I've shown them in black & white so you can concentrate on the light and dark areas rather than the colors.

Subject placement within the light is important. For the first two patterns shown here, short light and broad light, the subject should be on the edge of the window. More often than not, the chest of the female subject is turned away from the window. This way, the face is brighter than the chest. From this position, the subject

can turn her head back toward the window to produce a short light pattern. This pattern reveals the mask of the face. It is especially noticeable in a ¾ view of the subject's face. That is when a clean cheek is visible on the highlight side of the face and one ear is shown on the shadow side of the face. This is a happy light. Smiles are welcome here.

Broad light is the same ¾ view of the face, but this time the visible ear and the broad side of the face is illuminated. The mask of the face goes into shadow. This is a more serious, emo-

tional light. The deeper the shadow, the more somber the feeling. The placement of everything remains the same as in the short light, but the head just turns away from the window.

There are times when the subject looks more comfortable turned into the light. The same patterns can be used. I just add a gobo to block the light from hitting the chest. You can see in the examples the difference a well-placed gobo can make.

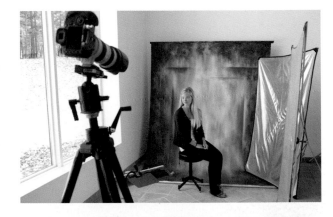

RIGHT ▶ Here you can see the camera and subject placement compared to the window. The camera is pretty much parallel with the window. This is the positioning for most "short light" and "broad light" portraits.

LEFT ▼ This image shows what a "broad light" pattern looks like. The face is turned away from the main light so that the mask of the face actually goes into shadow. This light may add weight to a subject so be careful when putting it into practice. In this image, the fill reflector was used to bring the relationship of the shadow closer to that of the highlight.

RIGHT ▼ Now you can see the same "broad Light" pattern with no fill. Notice the darker shadow side of the face.

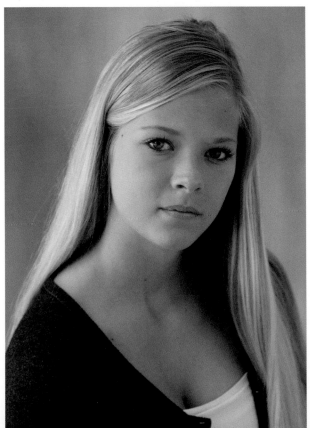

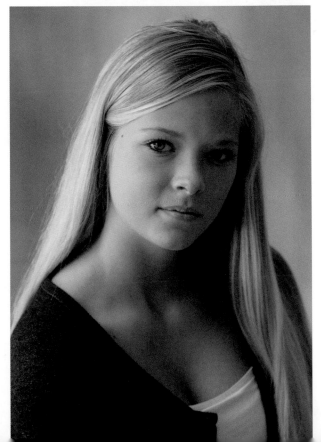

LEFT ▲ I usually choose to turn a female subject away from the main light. In some cases, you will find yourself in a position in which she needs to face it. The problem is that the chest reflects more light than the face, and it is a larger area. Unfortunately, the chest will draw more attention than the face. This is not a good scenario.

CENTER ▲ Here, a gobo was used to block the light from hitting the subject's chest. This allows the viewer to focus on the subject's face. Here, the model's face is in a short light position.

RIGHT ▲ This is the same gobo usage as before, but this time the model's face was turned to create a broad light pattern.

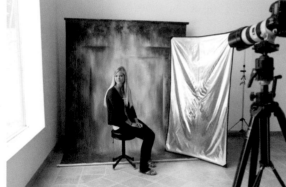

LEFT ◄ This portrait shows a Rembrandt light pattern. The mask of the face is mostly lit, but shadows help define a light triangle on the shadow side of the face. This is created by the position of the camera, subject, and light source.

ABOVE ▲ This is the overall view showing where the subject, camera, and window are positioned to achieve a Rembrandt light pattern. Rule of thumb: if you want a triangle of light, make a triangle with you, the subject, and the window.

Here is the setup used to create a split light pattern. I usually work the same as when using Rembrandt light, but I have the subject turn his or her face away from the window until I see the light stop at the midsection of the face.

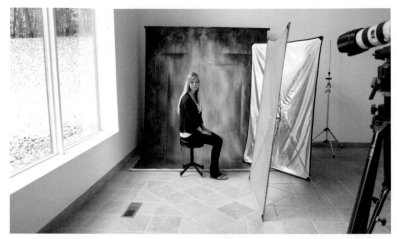

LEFT ▶ This image shows the split light pattern. A fill reflector was used to keep the shadow side of the face from going too dark.

RIGHT ▶ This is what the split light pattern looks like in my camera room without additional fill from a reflector panel. Remember, the walls on the south side of my camera room are reflectors as well and naturally fill the shadow side of the face in all portraits.

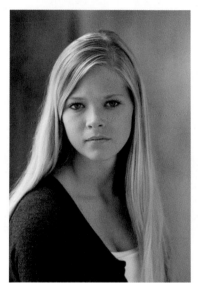 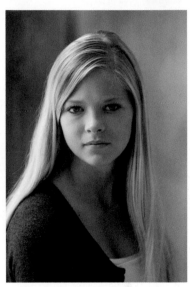

Rembrandt light is similar to short light, but it reveals a triangle of light on the shadow side of the face between the nose, eye, and cheekbone. This is a more serious light, one for a proper, sturdy pose and expression. It's easy to remember how to achieve this pattern. If you want a triangle, you need to make a triangle with the subject, the camera, and the light source. As you can see in the Rembrandt overview image (facing page), the camera position changed from parallel with the window to farther into the room to achieve this pattern.

Split light is what it sounds like; half the face is in light and half is in shadow. By now, you can probably guess that this is not a smiling light pattern. It is one used to show attitude, intensity, or concentration. To make this pattern, continue to move the camera away from the window and have the subject turn her face to follow you. When you see the light disappear on the shadow side, stop and record the image.

Profile light is used to dramatically show the profile of the subject. This light comes from behind the subject, who is posed with the shadow

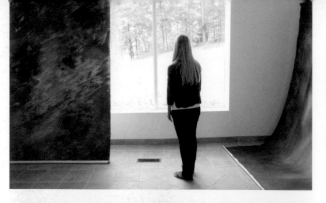

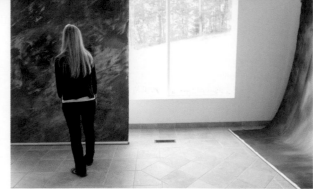

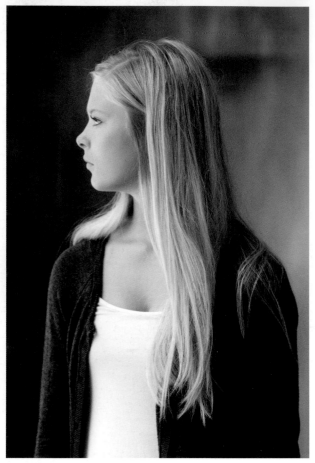

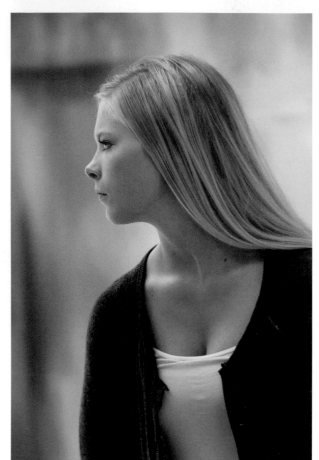

TOP ▲ More often than not, I see profile lighting attempted as shown in this image. When the subject is placed in the center of the window, the light engulfs her and creates spectral highlights on the face directly facing the light. The clothing (and bouquet if this were a bride) will be washed out and appear to glow. This happens even if exposed correctly. This is not how to light a profile.

ABOVE ▲ This is the result of placing the subject in the center of the window. Notice the flatness of the face and the washed-out hair.

TOP ▲ Here is the correct placement of the subject for profile light. The subject is on the same side of the window as the camera. If you were to stand in her shoes, looking forward, you would see the wall, not out the window. This forces the light to skim across the subject from the opposite side of the camera. This will produce a nice profile with detail.

ABOVE ▲ Here, you can now see the result of proper placement to create a profile light. Notice how much more shape she has and the detail throughout the image. *Note:* You still need to expose correctly for this. It is easier to use a light meter in this case because, from the camera position, the highlight is not very readable.

"Single accent is a dreamy, storytelling light pattern. The mask of the face is in full shadow. The only defining light is just skimming the side of the face."

Single accent is a dreamy, storytelling light pattern. The mask of the face is in full shadow. The only defining light is just skimming the side of the face. In most cases, the subject is looking down or away from the camera.

Double accent is just what it says. The defining light on the subject is on either side of the face. Usually, as with a single accent, the light comes from behind the subject and skims the sides of the face. Because the mask of the face is

side of their face toward the camera. This is a thought-provoking, emotional light. In most cases, it is best used for a more conservative expression. Many photographers are unsure as to how this pattern is produced with window light. I'll demonstrate with a few images.

First, the camera is positioned parallel to the window, just as with a short light. The subject is on the same side of the window as the camera.

Profile window light can make for a great bridal image. The dress will hold all its detail and the bouquet will not be blown out. If you want, you can add Mom and Dad on the other end of the window watching her. The light from the same window can give Dad a broad light and Mom a short light as they stand together and gaze at their little girl.

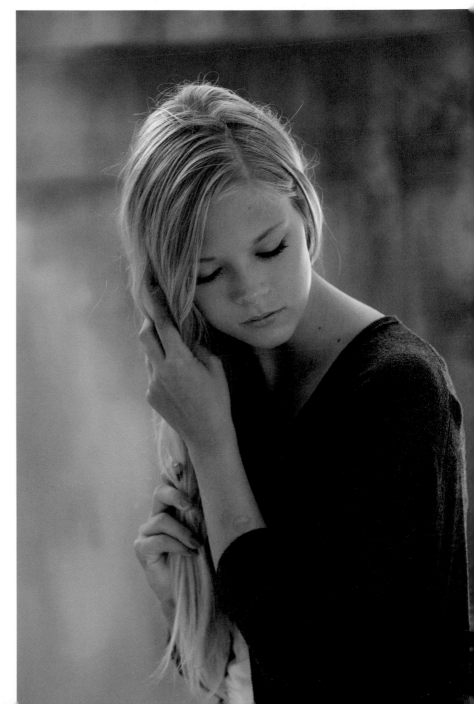

Here is an example of a single accent light. The face is in shadow. The only defining light skims across the edge of the subject. This is a good pattern for deep emotional images.

bad position

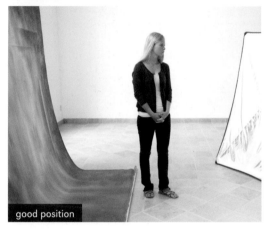

good position

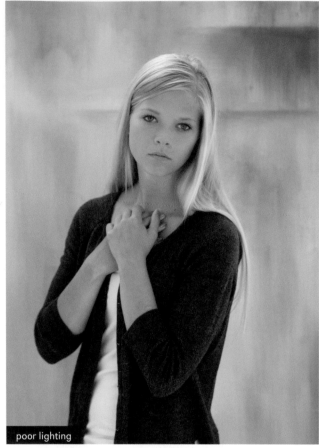

poor lighting

TOP LEFT ▲ This is not where she should be. Be careful not to position your subject out of the light. Move them away from blocking devices until they are at the edge of the directional light.
BOTTOM LEFT ▲ Now she is in a place where the light can do what it needs to. Find the edge of the light.
RIGHT ▲ This is what happens when the subject is too close to the blocking devices. Notice how flat the light is. It lacks texture.

in shadow, this is a more somber, thought-provoking light pattern. There are times when eye contact is made from the subject, but only if you are trying to portray a deep and powerful story. For either single or double accent, the subject needs to be positioned where the light just skims around the edge of the background. In my case, the background is against the bright window. I employ a second background as a "slip" so light doesn't come through the canvas.

Study the images on these pages. You will see examples of these light patterns. Each and every pattern can be created with small or large light sources. As I stated earlier, the difference will be the harshness of the shadow that defines the pattern. The images will also have various amounts of fill. You will see all of these patterns put to use in the next section of this book.

"Every pattern can be created with small or large light sources—the difference will be the harshness of the shadow defining the pattern."

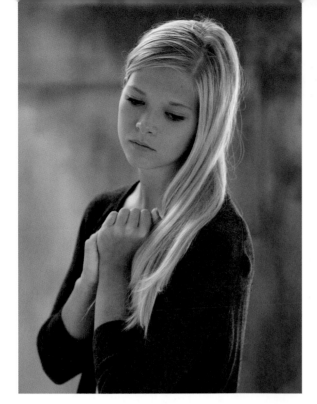

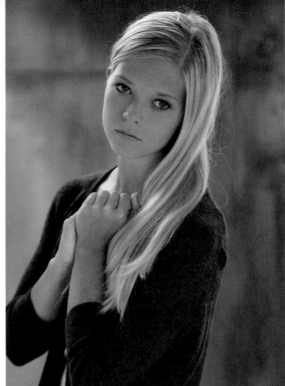

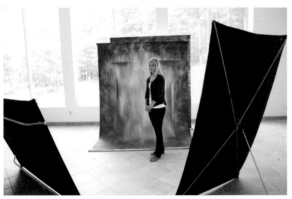

BOTTOM LEFT ◄ Here is an overall view from the camera position. This setup can work for single accent or double accent patterns depending on the subject placement and the subject pose.

TOP LEFT ▲ Now you can see the result of a double accent light. Most of the time, I have the subject look away from the camera to help with the mood from lack of light on the face itself.

TOP RIGHT ▲ The exception to the rule. This image was also made with a double accent, but this time, there is eye contact. Sometimes the subject's expression and body language allows it. It can make a powerful image. I still wouldn't suggest having the subject smile from behind this shadow—it could be kind of creepy.

THE RHYTHM OF LIGHT

Light rhythm refers to the relationship between the highlight and shadow areas of the subject and what is directly behind the subject. The highlight side of the face should have a darker tone behind it. The shadow side of the face should have something relatively lighter than that of the highlight side. This sends a push-pull message to the viewer's brain. Anything light on a flat piece of photographic paper will appear to advance. Anything dark will appear to recede.

In our minds, when the subject and background contrast with each other, depth is created. Also, since we are not working with background lights, ensuring that light rhythm exists will allow for separation between your subject and the background. Not every background will allow for this opportunity. If it can exist, it will make your images more powerful. Shown here (page 28) is the same image, with the same background, in different locations.

LEFT ▶ I painted this simple but well-thought-out background years ago. I needed a backdrop that helped with overall shape and form. Remember, in natural light photography, there is no background light. There is only subject placement and background relationships. We need dark areas to contrast highlights and light areas to contrast shadows.

RIGHT ▶ To show exact conditions with only the background changing, I created this photo on the green screen. By extracting the subject and changing her relationship to the background, I can show the impact that light rhythm can have on your image.

LEFT ▲ An example of good light rhythm. Notice how the highlight on the subject is lined up with a darker area of the background. On the shadow side of the face the background transitions into a lighter area as compared to the highlight side. Great depth is created.

RIGHT ▲ Now the subject is moved into an area that is just the opposite. Notice the lack of depth. In fact, the subject seems to blend in instead of jumping off the page.

To show how light rhythm works, I photographed my subject against a green screen, then cut her image out and placed it in a position against this backdrop that allows for good light rhythm. In the first image, we have a rhythm of dark (background) against light (subject), dark (subject) against light (background). The other has just the opposite. Which one stands out?

OUTDOOR SUBJECT PLACEMENT

Cloudy days are often said to be better for portraits because "you can photograph anywhere." This is not true. I do like cloudy days because they allow for more options for backgrounds, as they stay in a consistent tonal range. The art of lighting a subject still remains the same, whether cloudy or sunny. You need to work in an area that allows for good directional light. The question is where. Here is a simple answer. First, find a cover to stop light from above, just as you would indoors. Be careful not to go too deep under the cover and lose the light. Second, make sure light can only enter from where a main light would be positioned. This is a hard lesson to learn, so I will give you a simple-to-remember trick. Go sit where you were planning to pose your subject. Look around. If you can't see a main light source where it should be, or where you would have placed a strobe, you are in the wrong place. Find a new area. Think in terms of where the camera will be. When the camera is there, is the background acceptable? When the background is acceptable, will the

LEFT ▲ When you place the subject too far under the tree, the light gets flat and the color is contaminated.
CENTER ▲ The subject is in an open yard on a cloudy day. Notice the dark eye sockets and washed-out hair. The background is without spotty light, but this is not the most appealing place for the subject to exist. The fact that there are clouds in the sky does not mean that we can work just anywhere.
RIGHT ▲ Whether you are shooting on a cloudy or sunny day, trees, overhangs, bridges, and canopies are good options—just be sure your subject is not too far under them. You'll need to make sure that good, uncontaminated light is able to reach your subject.

LEFT ▶ Here, the subject is under the cover of the tree and the background is consistent because of the cloud cover. Notice the brighter eyes and the added detail in the hair on top of her head.
RIGHT ▶ The subject is too far out in the sun. There are hot spots on her head, shoulders, and the background. These areas will be impossible to "fix" in Photoshop. This is not the area to shoot in.

light pattern you want to achieve be possible given where the light is coming from? Just because you are outside doesn't mean the rules can be thrown out the window. (Okay, that was a bad choice of words, but you get the idea.)

The images below and on page 29 show you what to look for and what to avoid. Read the captions and study the images for future reference.

Remember, find a good background. Make sure there is good light to use with that back-

ground and the potential subject. Let the subject exist within that space, then record the image.

The rest of the book contains many images and the thought processes I went through to create them. I hope that during your time with this section, something will help you in your journey in the art of natural light portraiture.

LEFT ◄ Here, we have better placement of the subject, but the background still has problems. She is out of the raw light and the image will hold together for printing, but the background is washed out over a large area. This brightness will take away from the subject. It would be very time-consuming to "fix" in Photoshop. Even if the time was spent fixing the image, chances are it would never look quite right.
RIGHT ◄ The subject is still in a good location and an under-reflector was used to get just a little light in her eyes, but the background is still sunny. It's not as objectionable because a 70–200mm lens was set at a 195mm focal length to compress the area.

LEFT ◄ Now the subject is in a good location and there is a light cloud cover, but there are too many distractions in the background. This was done with a wide-angle lens. Many times a wide-angle lens can show too much of the surroundings and distract from the subject.
RIGHT ◄ Here is a well-placed subject with a background controlled by clouds and a good choice of lens. The subject is in the same place as in the last image. Just the lens was changed. Now her eyes are bright, there are no hot spots in the background, there is detail on the subject in highlight and shadow areas, and the longer lens both narrowed down what you see behind the subject and compressed the background to help separate the subject.

Unplugged:
Natural Light in Practice

1. TOO TUFF

THE CONCEPT

This image was created to show dedication and work ethic. I used the subject's football helmet as a prop to help tell his story. I kept away from the full uniform and decided to keep the ripped jeans. I felt the jeans told the story of his work ethic off the field. It is my opinion as a coach that an athlete is more than what we see on the field. One who is willing to help others and works hard on his own without being asked is a winner in my book.

THE SETUP

I positioned my canvas background against the windows in my studio. I opted to point my camera directly toward the light. The key here is to position the subject right where the light travels from either side of the background. The background itself is a subtractive light source.

If there is a rock in the middle of a river, water will flow around each side of it in a V shape. Light will do the same thing. Knowing this, I pulled the subject forward from the background until I could see the double accent I was looking for. I also brought in two reflectors. I placed them on either side between myself and the subject and feathered them toward him as a fill light. In this way, I was able to keep the shadows and highlights in a printable range.

The light from the window came over the background and served as a hair light. This is one of the benefits of having tall windows.

As the mask of the subject's face was in shadow, I asked him to look at the camera intensely. With some mist from a spray bottle, the story was complete.

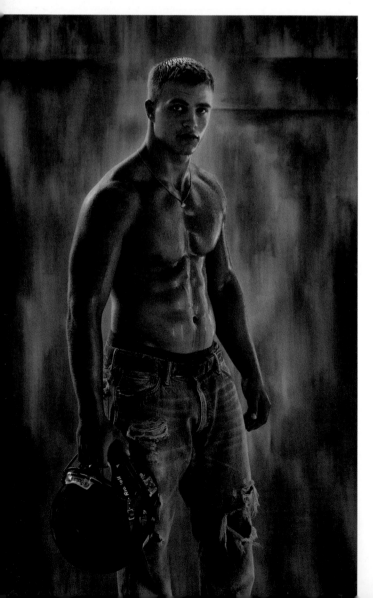

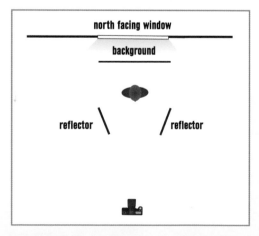

Canon EOS 5D Mark II • Canon EF 70–200mm f/2.8L IS USM lens at 90mm • $^1/_{30}$ second, f/5.6, 400 ISO

2. THE TILE PAINTER

In 2008, I was invited to do a program for the Mexico National Photographer's Convention in Puebla, Mexico.

A local photographer took several of us on a drive to see and record the area. We stopped at a ceramics shop where visitors could watch artists make pieces. I came across this gentleman. His job was to hand-paint tiles.

LIGHTING AND EXPOSURE

The subject was seated next to a tall, narrow window in a small room. I took a step into the room, then a step to my right. I looked through my camera and thought, "I'm seeing the meter read f/4 at $1/200$ second, but I know the highlight is at least a stop over that. I'll set the aperture to f/5.6." This was a profile pose. Since the light was coming from behind the subject, it was a profile light situation. The pose and light matched.

The shot was a happy accident. The painter happened to be near that window in a position that I recognized could work as a dramatic profile light. Watch for these occasions. The ability

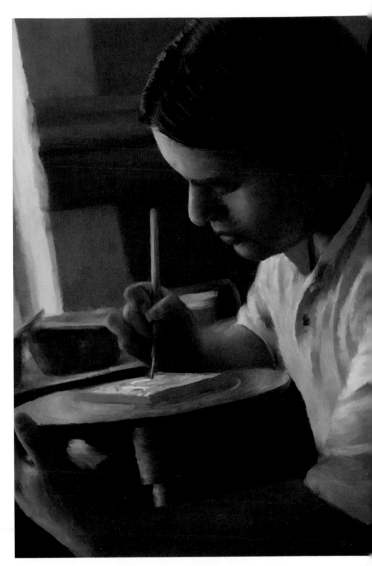

to see what is possible will greatly impact your work.

POSTPRODUCTION

I used Corel Painter to enhance this image. This was one of my first attempts at postproduction painting. I felt it was appropriate given the subject and his craft. A painter should be painted.

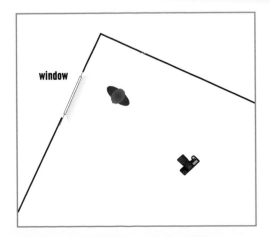

window

Canon EOS 5D Mark II • Tamron 28–75mm f/2.8 lens at 50mm • $1/200$ second, f/5.6, 1600 ISO

3. DOWN THE ROAD

This image was created during a senior session at the subject's home. The skies were heavily overcast, which allowed me to work in open areas with the background remaining in good workable tonal ranges. It is often said that cloudy days are best for outdoor portraits because the light will be better on the subject's face. That can be true, but the best thing about overcast days is good background tonality.

DIRECTIONAL LIGHT

When you are working outdoors, it is important to find or create a direction of light to give the face dimension. Cloudy days can make it more difficult to see good defining light on your subject. Ignore the fact that you don't have hot spots in the background and look at the scene as if it were not overcast. For example, as you can see in the diagram, I found an area where light was blocked from the left and was allowed to enter the scene from the right. The subtractive effect from the hedge gave me some of the light direction I needed to shape the subject. In theory, that would be all that is required to create great portrait light—but wait! The sky was still brighter than what was coming from the right side of the image. For this reason, I positioned the subject within the light to help with the light pattern. I had her tip her head and turn her chin slightly up and toward her shoulder. The light from above suddenly worked as the main light and fell onto her face and into her eyes in a comfortable way.

AN IMAGE WITH STYLE

The driveway and landscaping harmonized well with my 70–200mm lens to create wonderful perspective. By positioning the subject within the driveway, but off to one side, depth was evident. I also chose the clothing to match and blend with the driveway. (Doing the shoot at

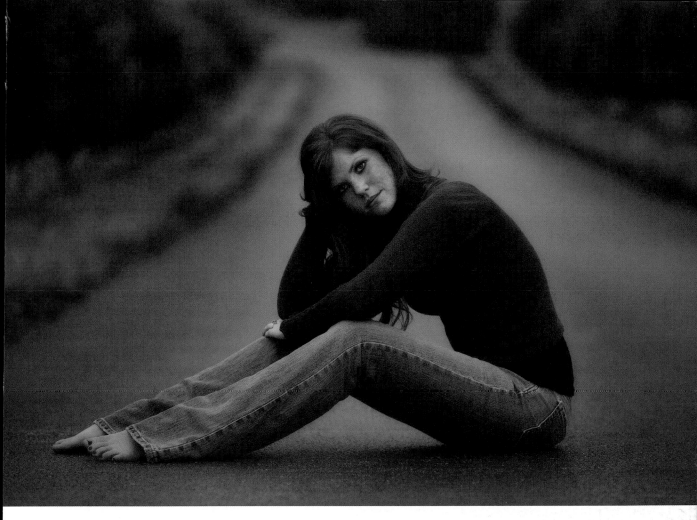

her house was an advantage. We went right to her closet and picked out clothing for the different backgrounds I was seeing in my mind.) The green in the landscaping was a perfect contrast for her red hair. I knew she would jump off the page, but more attention would go to her face because of the lighting and the use of color.

"I knew she was going to jump off the page, but more attention was going to go to her face because of the lighting and the use of color."

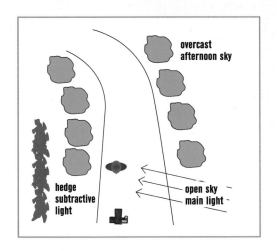

Canon 1Ds Mark II • Canon EF 70–200mm f/2.8L IS USM lens at 200mm • $^{1}/_{320}$ second, f/4, 400 ISO

4. CAMOUFLAGE

CULTIVATING SIMPLICITY

This portrait was made for a conservative senior who loves hunting and the great outdoors. I had worked with this family in the past and knew they wanted good portraiture, but in a simple way. Instead of using a bunch of props— guns, archery equipment, and fishing paraphernalia—I used his camouflage sweatshirt and a woodsy background. The key here was to create simplicity in a busy environment.

LENS SELECTION

I chose my 70–200mm f/2.8 lens for this assignment. I knew that the lens would give me a narrow field of view and would help compress the background for the simplicity I was looking for. I chose an aperture of f/4.5, as I wanted a shallow depth of field to help simplify the busy background.

THE RHYTHM OF LIGHT

I positioned the subject under the tree to stop the light from coming straight down on him. The trees on the left blocked light from that side. The open yard allowed the main light to enter from the right side of the image. There was a lack of light in the teen's eyes, so I brought in a reflector on the main light side and skimmed the light across his face until I could see life in his eyes. I wanted to bring the shadow side of his face up in value. To do this, I needed another reflector. This time, the light pointed back at the main light and skimmed the shadow side of his face. Next, I needed separation. I couldn't get a reflector behind the subject to create an accent light, so I needed another way to make him jump off the page. I used the light and dark areas of the background for this. The dark tree trunk and dark-green leaves lined up directly behind the highlight side of the subject's face. Behind the shadow side of his face, lighter green leaves appear. This relationship between subject lighting and contrasting background tonal values give the illusion of separation in a natural way. This is something to look for when creating an image. Look behind your subject and position them or yourself in relationship to them to find this rhythm of light.

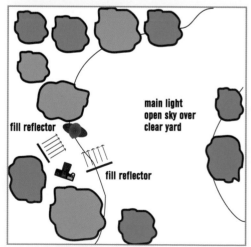

Canon 5D Mark II • Canon EF 70–200mm f/2.8L IS USM lens at 120mm • f/4.5, $^{1}/_{200}$ second, 800 ISO

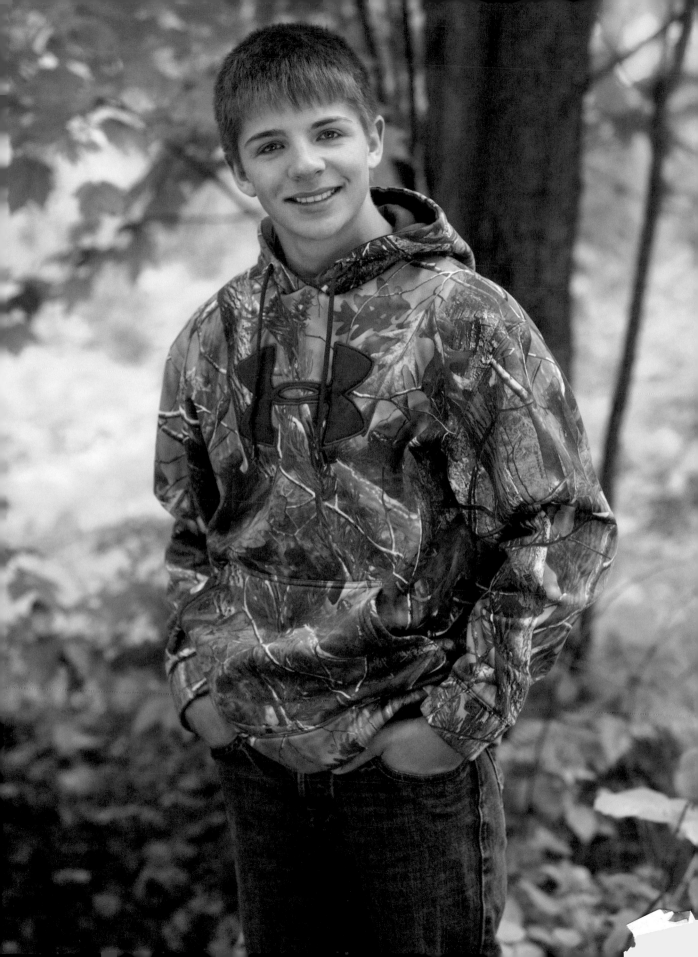

5. STAIR MASTER

While teaching a class in Cape May, New Jersey, I came across this stairwell. The end of the stairwell had tall windows within each story of the building, but the windows were not very wide. I wanted to get the composition and depth of the staircase and still use the light from the natural environment.

VISUALIZING THE SHOT

I began by looking through my camera from several stories above. As I chose my background, I visualized where the subject could be positioned. I looked for just a corner of the stairs above where the subject was going to be and composed the image showing the stairs below repeating as they got farther away.

I then instructed the subject to move into the space. Once positioned, I realized it would be a split-light situation. I had her turn her head toward the window until I could see the desired pattern. There was too deep of a shadow. I had one of the students hold a silver reflector to add fill from under the staircase to the right of the subject. This brought the relationship of shadow versus highlight into a range I was happy with. Since it was a split light pattern, I had the subject give me a stern look.

WHITE BALANCE

The entire scene was red, so the light entering the area created an overall red cast, even with a custom white balance. I used Nik Software's Silver Efex Pro to produce the conversion from color to black & white. In the program, I used a red filter to give a good contrast to the contam-

"Light alone is not enough. The entire story also needs ingredients from the subject, the location, and the presentation to be complete."

inated skin and create a better visual of the red staircase.

TELLING A STORY

The emotion in the subject's expression, the split light, and the black & white presentation led me to title the image *Stair Master*. Light alone is not enough. The entire story also needs ingredients from the subject, the location, and the presentation to be complete.

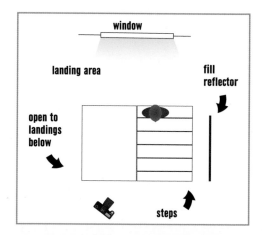

Canon 1Ds Mark II • Canon EF 70–200mm f/2.8L IS USM lens at 78mm • $^1/_{100}$ second, f/4, 800 ISO

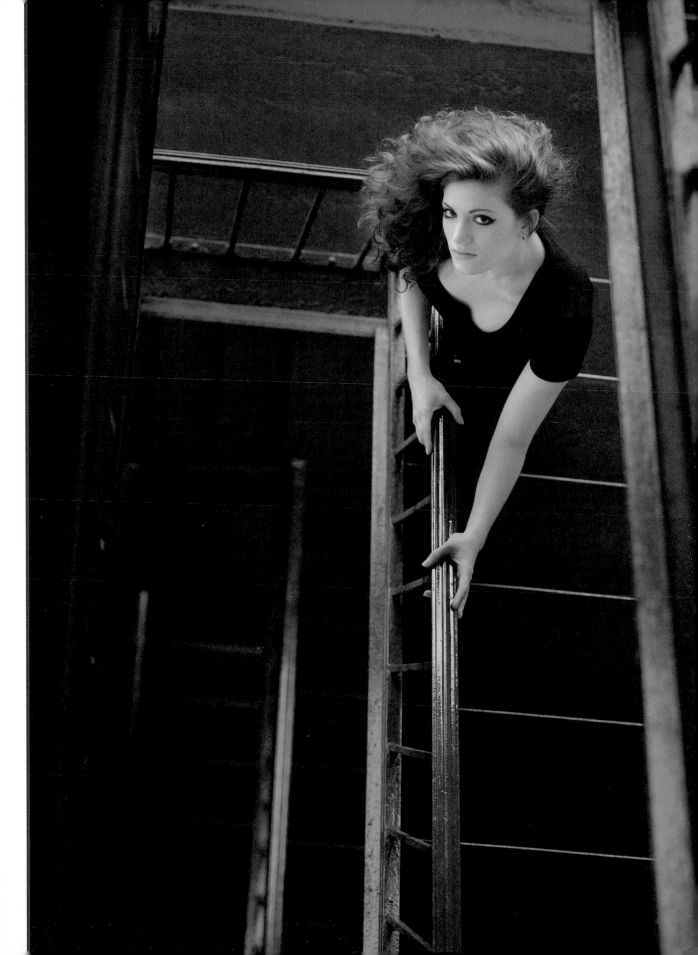

6. YELLOW AND BLUE

COLOR AND COMPOSITION

This high-school senior wore a yellow shirt and blue shorts to her session. I had the perfect place in mind for a set of images with this outfit. We walked down to my photo shack and began to play. I positioned her so I could see the yellow wall behind her. Instead of just plain yellow, I decided to maintain a bit more depth and allowed the floor and the blue wall just over her right shoulder to show. The little square of the blue wall was just enough to harmonize with her blue shorts. Between the two blue objects, her face exists.

This portrait is a good example of using color to guide the viewer's eye through an image. The blue shorts are obviously part of the subject, but the blue wall is far behind her. The composition lends a sense of depth to the image.

POSING AND LIGHTING

We did some images showing the shorts, but this pose showed them in a way that was more concealing. By bringing her left leg up, I covered her midsection and the length of the shorts themselves. Of course, with her leg up, there was an apparent weight gain on her bottom. The solution was to crop the shot. I didn't need to show her entire body; it was more important to draw attention to her face.

With this crop, I needed to find something for the subject to do with her arms. I created a circular shape comprised of her arms and face. This shape keeps the viewer's eyes from drifting away from the subject.

There is a soft Rembrandt lighting pattern on the teen's face. It is difficult to see because the light source is so large and the shadows are not very defined, but it is a pleasant pattern and very flattering for her. The soft expression seemed to fit the lighting pattern nicely.

I used a bit of fill, as shown in the diagram. I also used a reflector on the highlight side and from under the subject to add life in her eyes.

Tip: Be sure that your client does not smoosh her face or arms when she leans against something. Encourage her to lean against bone rather than soft tissue. This approach maintains the human form better.

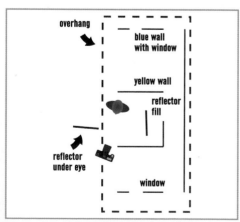

Canon 5D Mark II • Canon EF 70–200mm f/2.8L IS USM lens at 100mm • f/5.6, 1/160 second, 400 ISO

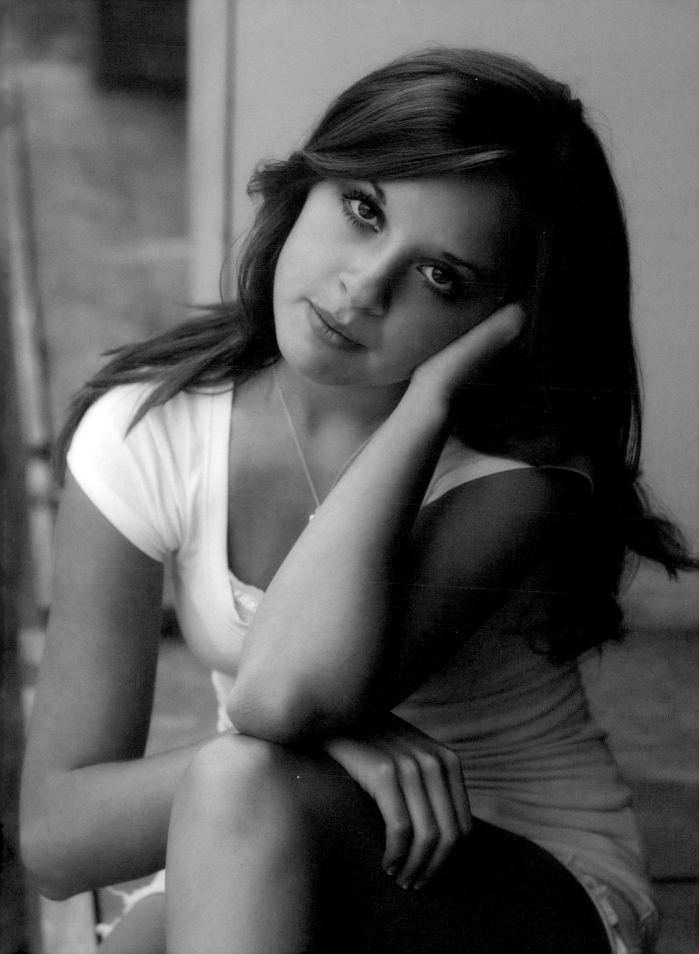

7. SKATER BOY

Okay, I *did* say not to go out and shoot in direct sunlight. That's a good rule of thumb for more traditional portrait scenarios. In this case, however, my subject was not too traditional. His story was to be told out in the bright sun with asphalt under his feet. I could have made this easier and brought out the "f-word" (flash!), but the look I was after was easy to achieve with natural light.

I knew it wouldn't be practical to use the sun as a main light. In fact, I chose to do just the opposite. I put the subject and his skateboard in a position to hide the sun. A thin layer of clouds helped too. I placed a large reflector to camera right to fill the shadow covering his body and face. The reflector was inches from his foot and just out of the camera view. Notice it was not pointed straight at him, but rather skimmed across him. This way, the only defined shadows from the subject came from the sun. The fill reflector was used to bring the shadow values closer to the highlights.

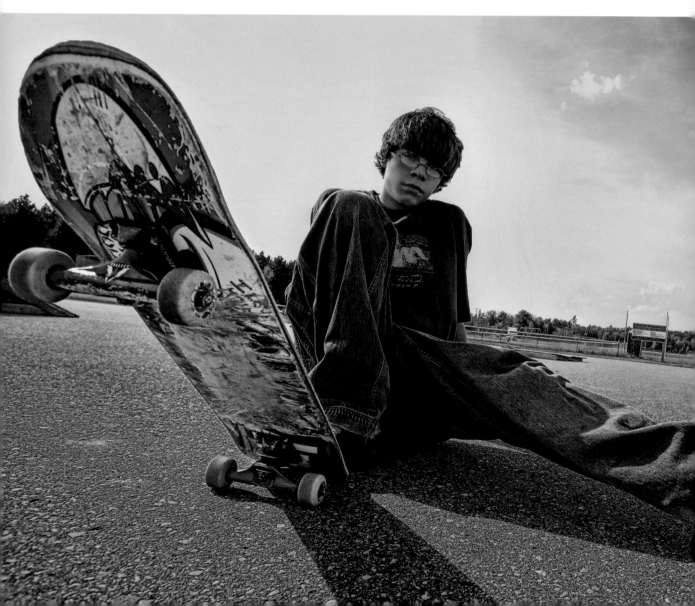

THE PROP

Next on the storytelling agenda was the skateboard, which was an important part of the image and the subject's life. Without the skateboard, it would not make sense to pose the teen on the pavement. Because of the prop's importance, I felt that I should add light to draw more attention to the skateboard. I placed a small reflector just beyond camera view and under the board. This reflector helped make the colorful board pop and added light in subject's eyes. Since it was so bright, I had the teen close his eyes while I set up the reflectors. I had him quickly open his eyes long enough to know where I was and freeze himself while he

> "Because of the prop's importance, I felt that I should add light to draw more attention to the skateboard. I placed a small reflector just outside camera view and under the board."

closed his eyes again. On the count of three, he opened his eyes and I recorded the portrait.

PERSPECTIVE

I used a 16–35mm lens for this image because I wanted to show a lot of the environment. A skateboarder needs space. I found a place near the fence so I could incorporate a sense of depth as it got farther away. I gave him a wide, skater-esqe pose and coached him to give me a stern expression. The low camera angle was chosen to hide the sun and present nothing but the sky behind him. I used his board and his orange shoelaces as points on my compositional triangle. His legs filled in the gaps, leading us right to his face. His story was told.

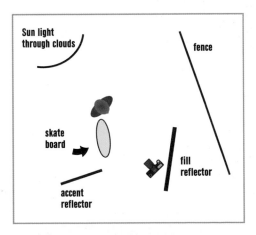

Canon 1Ds Mark II • Canon EF 16–35mm f/2.8L USM lens at 16mm • $^1/_{125}$ second, f/8, 100 ISO

8. ALLEY GIRL

This senior portrait was made on location. I traveled an hour and a half to a place I had never seen before. There was no time to scout the area; I simply had to roll with it.

A HARMONIOUS SCENE

I noticed the warm tones in the buildings and the way the structures related to each other. I also thought of the brown grass, blue window frames, and the perspective of the window sills. I needed to make them all work together and harmonize with the subject. I made sure she was contained in the grass, with no distractions.

Then I lined up the window frames just off to her left in an asymmetrical composition. The lines of the window sills and dead grass lead us past the subject, but when we get to the blue frames, our eyes bounce back to her. Her blue jeans are the secret. Blue is the only pop of color in this otherwise monochromatic scene. Because the same color exists on the subject and a well-placed background feature, a sense of depth is created. The viewer, however, will always go back to the in-focus subject.

LIGHTING

The lighting was simple. It was all about positioning her within the light. There was raw sunlight on the ground in front of the teen just outside of camera view. I walked her back until she was shaded by the building but close to the edge of the light. There, I had a large light source with good direction. I could pose her in various ways and choose many different patterns of light for her face. For this shot, I lit the mask of her face and let her be happy. It suited her.

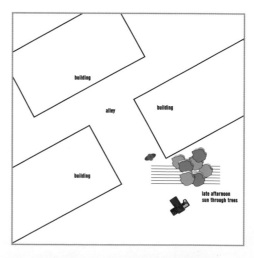

Canon 5D Mark II • Canon EF 70–200mm f/2.8L IS USM lens at 85mm • ¹/125 second, f/5.6, 400 ISO

9. GIVE ME THREE STEPS

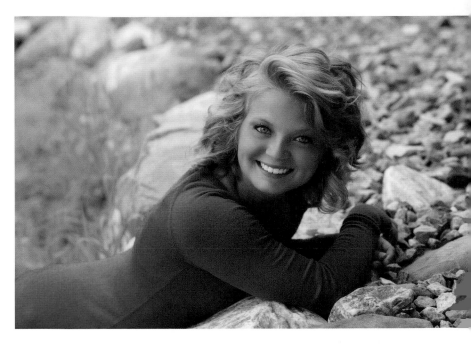

When I began work on the retaining wall outside of my studio entryway, I started laying the rocks in a straight line, parallel with the house, but then I thought, "Why not create a compositional element I can use in a portrait someday?" So I rearranged the rocks, filled in the low areas, and added decorative stones on top. I planted a tree to help break up the large open wall and to give a blocking device for later portraits. The visualization paid off. I use this area quite a bit. In the summer, this location is in shade until about 10:00AM. That gives me plenty of time to use the area with my first sessions of the day.

Grass grows near the rocks, so the green color accented the subject's green eyes. The decorative stones worked well with her outfit.

POSING FOR THE LIGHTING

The pose was simple. I noted where the light was coming from and positioned the subject at an angle that allowed the light to reach her face. The secret is to pose for the light, but also for the subject. Sometimes what we have in mind does not look comfortable when the subject does it. When this is the case, try something different. In the end, the light has to be pleasant and the pose needs to be comfortable.

REFLECTOR FILL

I positioned a reflector under and to the highlight side of the subject to brighten her eyes. No added reflector fill was needed. The studio building is a light-cream color. The building cast a large shadow over the area. The wall acted as a soft reflector, bouncing light from the open sky and adding the fill we needed for a flattering image.

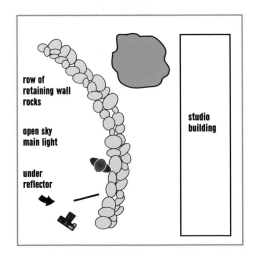

Canon 5D Mark II • Canon EF 70–200mm f/2.8L IS USM lens at 90mm • $^1/_{125}$ second, f/5.6, 400 ISO

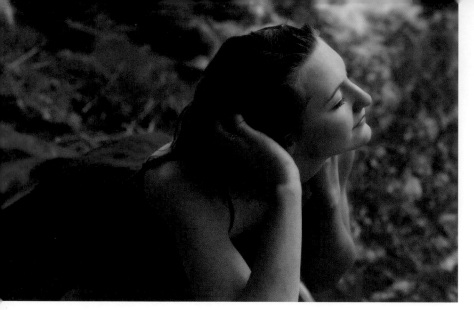

10. RIVER WATCH

BEAUTY VERSUS DEVASTATION

I was teaching a class in Colorado several years ago. One afternoon, we took a walk with this high school senior girl to find areas to trash her prom dress. Just because one thing is on your mind doesn't mean you can't alter your plans along the way. This area looked clean and pure. I wanted to show beauty here, not devastation.

SURVEYING THE SCENE

As we came to this bridge, I noticed a lot of nice light coming from an opening created by the bend in the river. I looked through my 70–200mm lens and scoped out a background showing some water. There was a large rock for posing on. I walked down to the rock and took a light reading with my hand-held meter, then I helped the model maneuver down the bank to the rock. I posed her in a profile position because the light was in favor of that pattern in relationship to the camera position. I fixed her hair and scrambled up the bank to the camera to capture this image.

What made me stop here? The river cut an opening in the trees for the light to enter the scene. As you notice in the diagram, the only place light could come from was behind the subject. The trees on both sides of the river acted as a subtractive light source and the position of the camera from above only showed darkness behind the subject. The subject was then sculpted within the scene.

LENS SELECTION

Using a 70–200mm lens was a key factor in the success of this image. By narrowing the field of view, I was able to isolate an area behind the subject that didn't have raw light or other distractions. It also compressed the background, allowing the subject to stand out even more.

Canon 5D Mark II • Canon EF 70–200mm f/2.8L IS USM lens at 120mm • $^1/_{125}$ second, f/5.6, 400 ISO

11. UNDERGROUND

When I work with a senior outdoors, I tend to make things up as I go along. This way, the teen will have something that no one else has. Senior portraits should be unique. Yes, there should be some constants, but you should do a few things to produce unique looks.

AN URBAN STAIRWELL

This stairwell leading to a basement looked like a good location. The background was different and pleasing, and the light was good. How did I know the light was good before the model was in place? Practice. Plus, the building cast a shadow over the stairs. The only direction light could come from was the open sky over the street. I knew the light would cross from right to left.

COMPOSITION AND LIGHTING

I had the model walk down the stairs until she was framed by the back wall. Her head was the only part of her body above ground level. This ensured that it would be the brightest part of the scene. The back wall was important for more than just simplicity. It also had rhythm potential. The dark bricks could line up just behind the highlight side of her face. The shadow side of her face could be presented against the lighter bricks. By positioning the camera just right I was able to make the separation visible.

Canon EOS 5D Mark II • Canon EF 70–200mm f/2.8L IS USM lens at 80mm • $^1/_{30}$ second, f/5.6, 400 ISO

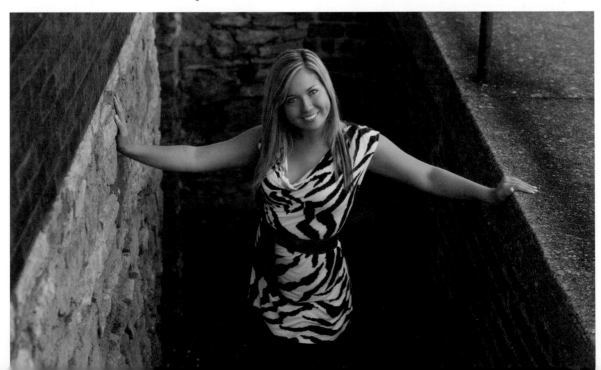

12. PLAYING POOL

THE FINALE

I photographed this girl for a trash-the-dress session. Colorado mountain water is cold in late May. Heck, we walked around many piles of snow during the session. To warm up and to finish the session, she jumped in the pool at the resort.

THE LIGHTING

There was good light coming in from the glass wall on the long side of the pool, and there was light coming from the far side. There was a patio above the pool across from the windows with a little set of stairs. The short wall up to the patio and the wall on the far side of it were solid and faced with wood. The entry side of the pool also had a solid wall. The only way for light to naturally get to a subject in the water was from the north and east sides. It was late in the afternoon, so the light coming from the east windows was from open sky, as was the light from the north-facing glass wall.

I walked around the pool to where I thought the light would be best. I had the model walk into the frame. Once she was within my camera view, I turned her until the light was nice. I used her dress to create a unique shape and to cover her underarms. Since the combination of her dress and her pose looked like a flower, I had her close her eyes to avoid making eye contact with viewers.

I liked how the warm color of her skin contrasted the cool color of the water. Even though I wanted the communication to be nondirect, I still wanted the viewer to see the human figure within the design.

Canon EOS 5D Mark II • Canon EF 70–200mm f/2.8L IS USM lens at 90mm • $^1/_{100}$ second, f/3.5, 400 ISO

13. WINDOW SEAT

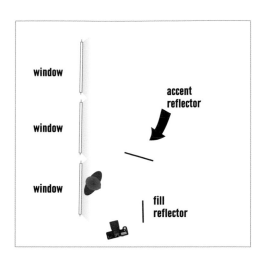

Canon EOS 5D Mark II • Canon EF 70–200mm f/2.8L IS USM lens at 70mm • $^1/_{60}$ second, f/5.6, 400 ISO

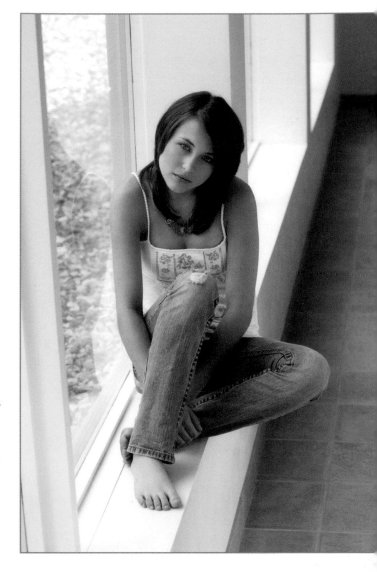

CLOTHING SELECTION

Before each session, I look through the subject's entire wardrobe. I separate colors, then with the help of the model, choose the best pieces within each color. I decide what will be used inside and what will be used outside or on location. The indoor choices are hung in order of what I am going to do. If I am set up with a dark background from the end of my last session, the first outfit will be darker in color. Preparation is key.

The subject had several white tops. All were nice and different styles. Instead of pairing each of them with the same light-colored canvas backdrop, I chose the window sill for this outfit. The windows themselves make a good background—especially in this case, as they repeat themselves as you look farther into the scene.

THE POSE

I just asked the teen to sit in the window. She posed herself. I asked her to turn her head until I had split lighting to complement her expression. I also placed a reflector for fill and one for accent, as shown in the diagram. Not all images need to be difficult. Simple is good.

14. WINTER WOODS

I live in the north woods of Michigan's upper peninsula. Our warm season is short. In 2013–2014, we had snow every month from October through May. That's eight months. That leaves four months to do sessions outdoors in a green, lush environment. Not everyone thinks to come in during those "gentler" months for portraits. Some folks brave the cold.

EMBRACING THE ELEMENTS

This senior wanted to be photographed in the snow. We worked inside first and took care of

the traditional things, then packed up and headed down the road.

SERENDIPITY

When I looked through the client's wardrobe, I found this sweatshirt. The first thing that came to my mind was that the pattern on it looked like the bark of poplar trees. When I saw this stand of poplar trees, I quickly pulled over. I had to work fast. There was a good-sized cloud covering the sun, but there was just enough intensity to create a good direction of light.

I found two trees together where I could see more trees behind them. I placed him against one tree, turned his face into the light, and recorded the image. Note that the highlight side of his face is against the shadow side of the tree behind him and the shadow of his face is against the lighter background. Look for these things; they can make your images more powerful.

I did not use a reflector for this image. My only light was the sun through the clouds. The tree at the subject's left acted as a subtractive light source. I chose an aperture of f/4.5 for a shallow depth of field and set the lens to 140mm for a narrow field of view. These two settings produced an image with a simple background despite the fact that I was working in an area where there was a great deal of potential for distractions.

Canon EOS 1Ds Mark II • Canon EF 70–200mm f/2.8L IS USM lens at 140mm • $^1/_{200}$ second, f/4.5, 400 ISO

15. FLOWER GIRL

This girl liked wildflowers, so late in the afternoon, we headed out to find some. It didn't take too long. The power line near the studio cuts a path through the woods, leaving good open areas for wildflowers to grow. Most of the areas are lined with trees and wooded country that stretches for several miles. The woods are home to many critters, including bears who frequent these open areas in search of berries or other food sources. It doesn't happen often, but every once in a while, we have furry photo bombers come through. This was not one of those days.

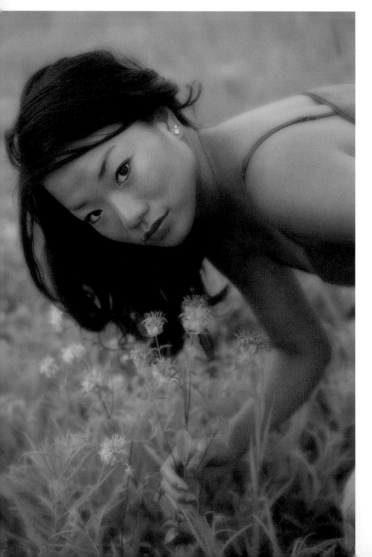

LOCATION LIGHTING

In this particular area, there was a depression from both sides of the clearing so the trees hung way above the field. The banks cast a nice shadow over the flowers and made for a nice consistent background that also had what the senior wanted. I created many images here, but this was her favorite. I also liked it, as there was good light, her hair looked good, and her story was told. The subject's hair hung down and acted as a subtractive light source. Yes, the main light was coming from the western sky, but the hair helped. The moral of the story is this: parts of your subjects can help light or not light other parts. Depending on what you see, position body parts to help you. As I have stated before, body parts can also help create a more powerful composition.

A SIMPLE BACKGROUND

I chose an aperture of f/4 for a shallow depth of field to help simplify the background. I set my lens to a moderate focal length, 70mm, to keep some of the field and flowers in view.

open field of wild flowers

Kodak DCS Pro SLR/n • Nikon 80–200mm f/2.8 lens at 70mm • ¹/₄₅ second, f/4, 160 IS

16. THESE BOOTS WERE MADE FOR . . .

I painted this canvas backdrop years ago. I use it to show the dark side of some people. As you'll notice, I painted light and dark areas for a subject to harmonize with and create a nice rhythm of light in relationship with the background.

This subject fit the dark side. She loved her boots and wanted to show them off. I thought that this backdrop repeated the pattern of the eyelets in the boots. The foot closest to the lens ran in a diagonal direction to the subject's face. The eyelets were perpendicular to the lines in the background. Where the two intersect, we see the subject's face.

SPLIT LIGHTING

The split-light pattern suits the portrait concept. I made sure the teen lined up within the dark and light areas of the background for separation. I placed the background at a slight angle to the windows so that I could get the split light pattern I wanted while keeping her square to the background. Normally in a studio, the background stays put and the light is moved. When working with natural light, the subject and the photographer need to move within the light.

I used a bright silver reflector for an accent light and a soft silver reflector for fill. The reflectors were placed to allow light to skim across her.

BIG SALES

When I made this image, I thought my clients might purchase wallet-size prints. As it turns out, her grandparents bought a 24-inch print of this pose. They were taken by the way it showed her personality. I guess you never know.

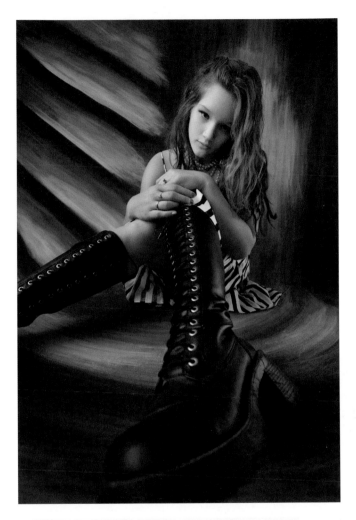

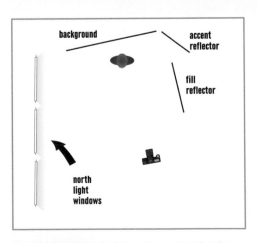

Canon EOS 1Ds Mark II • Canon EF 16–35mm f/2.8L USM lens at 16mm • $^1/_{30}$ second, f/5.6, 400 ISO

17. SWEET LIGHT ON THE BEACH, PART 1

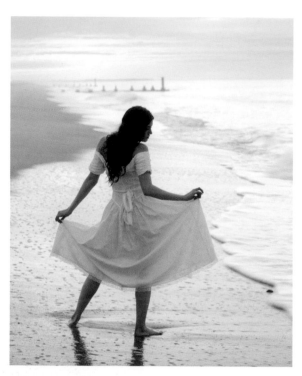

THE BEAUTY OF SWEET LIGHT

"Sweet light" is found when the sun is out of sight behind the horizon but the atmosphere is still light. This happens at sunrise and sunset.

These images were created during a demonstration in Cape May, New Jersey. The shoot required an early wakeup call and a good-sized cup of coffee.

The night before this demonstration, I went through the model's wardrobe and found this dress. I liked the simple beauty of it. It was light and airy with just enough texture to make it interesting. I knew it would be well suited to the pastel setting of the beach at sunrise.

Photographing this early in the day requires a tripod. Some of the exposures can be pretty long. If the model is in a sturdy stance, this

should be doable. The key to this kind of beach portrait is to work as soon as you have enough light to see. When the sun comes over the horizon, the game is over. It's a short window in which to create images, but it's magical.

When the light is right, the background in any direction holds favorable tonal ranges compared to the subject. This means the model and photographer can move in more angles to the light and create different light patterns without worrying about background problems. As long as the background does what you want for the composition, the subject will be the focal point.

THREE LOOKS

Image 1 (left) was inspired by watercolor artist Steve Hanks. His work is beautiful and inspiring. As I see it, watercolor painting is about the transparency and the art of working backward from the white of the paper to the colors involved in the scene. Here, I saw many layers of transparency. The dry sand, the wet sand, the shallow wave, the ocean, the dress, and the girl's figure. I also looked for depth in the background. By letting the beach fade off in the distance, the viewer gains a sense of space. The far-off pier gives our eyes a place to go, but it is perpendicular with the lines of the beach and stops us, turns us around, and sends us back to the model. Yes, it is a simple image, but one with a great deal of thought behind it.

Image 2 (facing page, left) was created a bit later in the session. The sweet light allowed me to move around the subject for a different light pattern and still hold the background tones. Yes,

I got my feet wet, but it was worth it because I had a light source that allowed me to create a short light pattern. The subject could make eye contact with future viewers.

It's worth pointing out that eye contact should generally come from a lighted mask of the face, or at least a split light pattern. People looking at you from within a shadow can be creepy—so light what is looking at you.

Image 3 (below, right) was created a bit earlier in the session. The subject and I moved away from the water while maintaining the same relationship with the light. This way, I could create a short light pattern. By turning the subject, a single accent sculpted her face. I let her look down with a somber expression to match the mood that was established by the light.

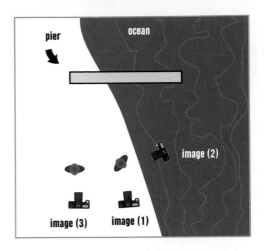

Image 1 (facing page). Canon EOS 1Ds Mark II • Canon EF 70–200mm f/2.8L IS USM lens at 70mm • $1/8$ second, f/5.6, 400 ISO

Image 2 (bottom left). Canon EOS 1Ds Mark II • Canon EF 70–200mm f/2.8L IS USM lens at 95mm • $1/100$ second, f/4, 400 ISO

Image 3 (bottom right). Canon EOS 1Ds Mark II • Canon EF 70–200mm f/2.8L IS USM lens at 80mm • $1/10$ second, f/7.1, 400 ISO

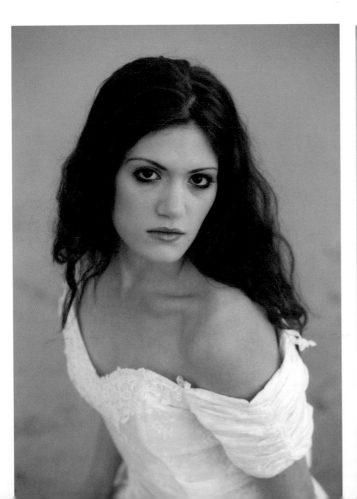

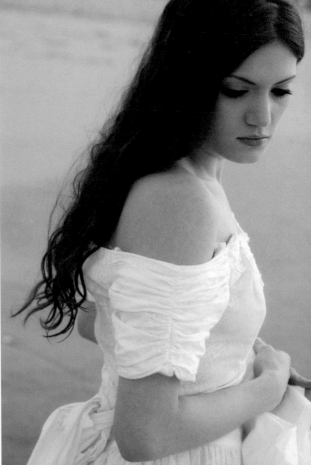

18. SWEET LIGHT, PART 2

FOCAL LENGTHS

These two portraits were made during the same session shown in section 17. The same exposure settings were used for these photographs: $\frac{1}{80}$ second at f/4 and ISO 400. Notice, however, that the images differ from one another. The first image (below) is a full-length scenic image.

It was created at a focal length of 70mm. The second image (facing page) was shot at a focal length of 140mm. Notice how the background blurs and the details of the scene blend together, leaving the viewer to focus on the subject.

There are so many variations we can produce in a scene just by knowing what our equipment

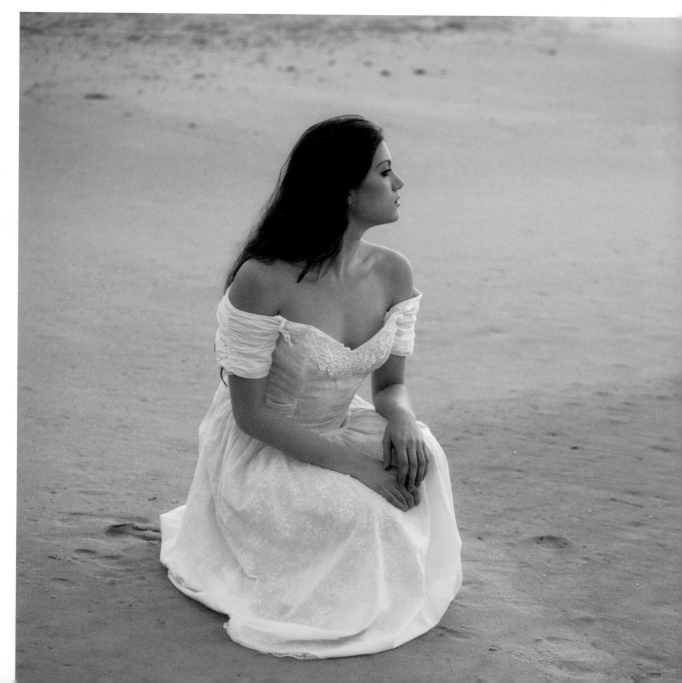

is capable of. Both of these images show the subject in a profile pose with good profile lighting. You can pose a subject in a profile stance at any given time, but you will find that the photograph will always be more powerful when the light is coming from behind the subject.

WORK SMARTER, NOT HARDER

Sweet light times are magical and easy to work in. This is why my outdoor family portrait sessions are all done in the evening. The light is better for subjects and backgrounds. Plus, that's when many folks are home from work. Don't battle. Work smarter, not harder.

"Sweet light times are magical and easy to work in. This is why my outdoor family portrait sessions are all done in the evening."

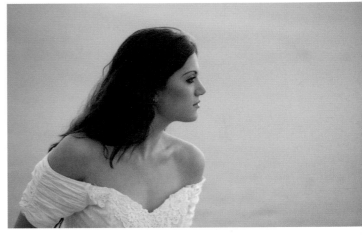

Image 1 (left). Canon EOS 1Ds Mark II • Canon EF 70–200mm f/2.8L IS USM lens at 70mm • ¹/₈₀ second at f/4 and ISO 400

Image 2 (above). Canon EOS 1Ds Mark II • Canon EF 70–200mm f/2.8L IS USM lens at 70mm • ¹/₈₀ second at f/4 and ISO 400

19. GLAMOUR GIRL

When I was in high school, Joe Kind was my wrestling coach, school yearbook advisor, and photography teacher. In wrestling, I learned discipline, attention to detail, and how to work hard to achieve a goal. I also learned that basics are more powerful than "fancy" in most cases. When "fancy" works it's because a skill was practiced enough that it became basic for that particular athlete/artist. Portraits with strong, basic ideas can and will impress more and sell more than "fancy" done poorly.

I was lucky. I learned right away that what happened in-camera (the foundation of the final image) will affect what *can* happen in the darkroom. Technical thoughts can work together with artistic thoughts. It is best to visualize your end result, then use your tools and skills to create what you have in mind. This way, when you get into the "darkroom" or, in modern terms, "post-process" your images, your work will be rewarded at a higher level.

A DREAMY LOOK

So, how do my life lessons pertain to this image? Well, in this case, I chose to use a long lens to take advantage of the subject-to-background compression that would result, plus a wide aperture for a shallow depth of field. The result was a soft, dreamy look right out of the camera. The clothing the subject wore was light in color. Her hair was light in color and looked quite soft. Then I noticed her eyes—the makeup she used beautifully defined them and made them sharp compared to the rest of the scene. I had her sit on the edge of my north-light window

so the entire wall of light could be used to give a very gradual transition between highlight and shadow. I wanted the viewer's attention to go to her eyes, so I had her turn her body away from the window and turn her face back toward the light. By doing this, her chest was shadowed by the rest of her body and her face was the brightest part of the image. I used one reflector to produce fill so the shadows wouldn't become dark and disturbing in this pastel, airy scene. A second reflector was placed under the subject and to the highlight side to enhance her eyes.

POST-PROCESSING

We use software to enhance our images these days, but the old darkroom tactics still apply. In the darkroom, I would burn and dodge to darken or lighten an area. I would use colored filters to create different contrasts and different looks to various colors in the image. Later, with the help of cold light enlargers, I could burn contrast into different areas as I saw fit. That was getting pretty advanced in the darkroom, but it was possible. Today, we have RAW files and can

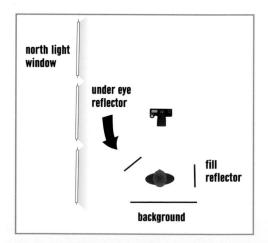

Canon EOS 5D Mark II • Canon EF 70–200mm f/2.8L IS USM lens at 165mm • $^1/_{200}$ second, f/4.0, and 400 ISO

use Photoshop's filters and third-party plug-ins to custom print an image with greater precision than was ever possible in the traditional darkroom. Yes, the means of image enhancement have changed, but the ideals still hold true: the basics are a foundation for even the most elaborate move. Start with something good from the camera, then use post-processing to enhance your results.

For this image, I used Nik Silver Efex Pro 2 to create several different outcomes with colored filters and variations in contrast. I then layered the images in Photoshop and painted (burned and dodged) the desired effect where I saw fit.

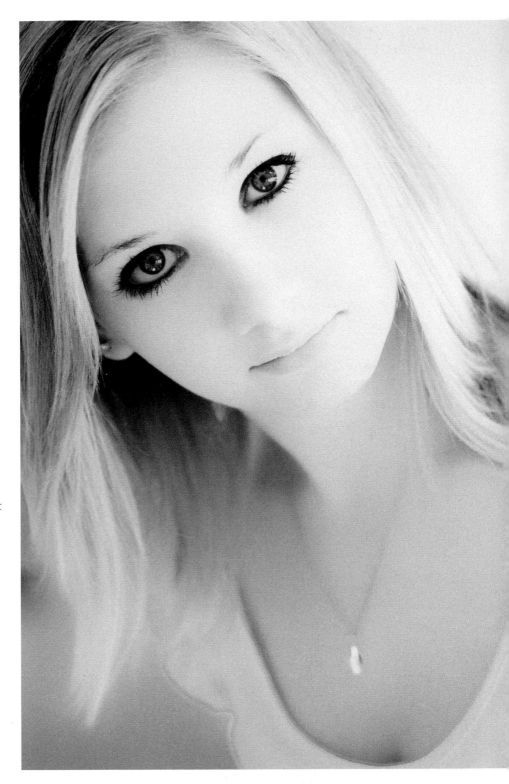

20. RED

THE PHOTO SHACK

I used to load a senior and parent into my vehicle and drive around to various locations to find buildings with character. There were inherent problems with this approach: (1) Gas prices are high; (2) more time was spent driving than creating; (3) the buildings kept getting torn down just as I got to know them. This is why I built the "photo shack" (see the photo on page 40). I tried to use old weathered material but realized that I could make it more than just an old shack. I painted the middle bay walls red and matched one sheet of plywood for extra length if I needed it.

VISUALIZATION

When I saw this subject's red shirt, I visualized using this area of the shack. Her shirt color harmonized well with the background, giving her a reason to exist there. For this image, I propped the red plywood in the corner to make a simple background for her and to create depth in the scene. Normally I would position my camera to point east or west and use the north light from the window, but not this time. This time the soft, north light acted as my fill light. The main light came from a reflector out in the sun. I feathered the direct light across the subject. Some of the reflected light also cast a shadow of the plywood on the wall behind her. I didn't foresee this; it was a happy accident. When I looked through the camera, I smiled. I knew it was going to be something special.

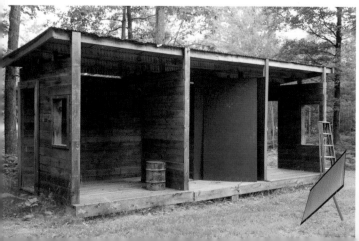

Yes, I usually like to find shade to work in, but don't be afraid to harness a bit of raw light from the area. Just be careful that you do not blind your poor subject by pointing the reflector right at them. It's uncomfortable and it will cause problems when it comes time to print the photograph.

"Don't be afraid to harness a bit of raw light from the area. Just be careful that you do not blind your poor subject by pointing the reflector right at them."

21. ALL ABOARD

WARNING!

This image discussion begins with a warning: *Do not photograph people on working railroad tracks or train cars.* First of all, it is against the law. Railroad tracks are private property and you shouldn't be on them. They are also unsafe. Trains are very large and extremely heavy. They move faster than you think and do not stop easily. It would be a real downer to walk away from one of your clients in handcuffs. It would be even worse if someone were hurt or killed. As of this writing, I have heard of four railroad fatalities linked to photography this year. Don't be part of this statistic. The tracks you see in my images are exempt and they are used for snow-mobile trails in the winter. The train car I use is in a lumber yard, and I have permission to go there. Be safe first and creative second.

LIGHTING

How did I get the light to do this? The key to this image, as is the case in many natural light scenarios, is timing. I can use this spot in the early morning or late afternoon. This particular image was made in the late afternoon. The overhang from the caboose blocked the down-light. The open sky to the east produced a nice fill. There was some light skimming over the top of the car behind the subject, creating a nice hair light. The main light was from the brighter open sky to the west. The direct sunlight was blocked by the train car itself, but there was still more intensity from the open sky to the east. You will notice even more direction from our main light because of the thin vertical ladder

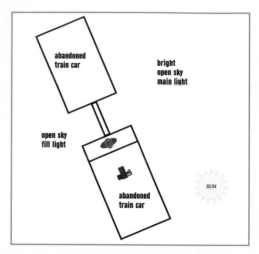

Canon EOS 5D Mark II • Canon EF 70–200mm f/2.8L IS USM lens at 110mm • $^1/_{100}$ second, f/4.5, 400 ISO

and the subject's arm acted as a subtractive light source. If she were to lean back away from the ladder, her face would have a double accent pattern on it. By moving her face forward, the light direction was only visible from the west.

A GOOD COMBINATION

Notice the background. I needed to use a fairly long focal length to avoid the raw light that was hitting the train car behind the subject and to our right. At other times of the day, this light may be able to be duplicated, but the background will become unusable. Remember, you need a good background and good light for your subject to exist within. Without one, the other just doesn't cut it.

22. LET'S JAM

At least once a year, a senior walks through the door with a guitar. This girl had a nice one and looked good with it. I decided to use classical lighting with an edgier pose.

POSING AND LIGHTING

I chose to bring the guitar up close to her cheek and aim the neck toward the camera. The light was pretty normal as compared to most of my work. She was positioned on the edge of the bank of windows so that I could fully use the north light as a main light source. One reflector was used for fill and one was placed under the model on the highlight side of her face. I turned her body away from the window and turned her face back into the light just enough to produce a broad light pattern. I asked her to not smile but to look a little happy and confident. Somehow she knew just what I meant—the expression fit the mood.

The guitar was on the shadow side of the subject and was tilted away from the window. I didn't want the window reflections on the guitar, as they would have been distracting.

BACKGROUND

The background was from Shooting Gallery Backgrounds. They do a wonderful job of painting. They also do a great job listening to you and painting to match your needs. This particular painting was created in the mirror image of what was in their catalog. When choosing a new background, look for shapes and patterns or light and dark areas you can use in relationship with the subject. Remember, there is no background light in the north light studio. The background must offer separation.

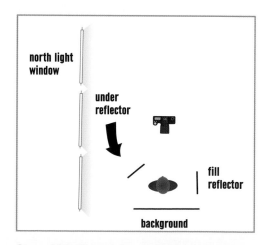

Canon EOS 5D Mark II • Canon EF 16–35mm f/2.8L USM lens at 29mm • $^1/_{125}$ second, f/6.3, 1600 ISO

23. DOVE GIRL

TATTOOS

If my client has a tattoo, I want to know the story behind it, as it will guide what I do for the image. This young lady had doves on her hip. Her story was deep and sad, as it was to memorialize the loss of a family member.

LIGHTING

A single accent felt right for this image. I wanted a bright, heavenly background. I thought one could also be the other. I placed her in front of the window. By exposing for her, the background would be overexposed to the point of a glow. I turned her face until I saw the light feather across her cheekbone and nose. There was at least a six-stop difference between the exposed light on her and the background. This worked in my camera room because of the white walls opposite the windows. The walls provided the fill light that created the exposure for her body, while the light from the open sky outside created the highlights on her face.

The ink is a secondary focal point to her face because her face has more dimension. The highlights that show her features attract attention. I made sure there was enough light on the ink to be easily seen, but it is the same light as on the rest of her body. By placing her hands diagonally on either side of the artwork, attention was drawn to that area. It all comes back to the light background. Her hands are dark compared to everything else. The shadow side of her face is the same density as her hands. Her hands and face make a triangle that we follow with our eyes. Along this followed path, her story is told.

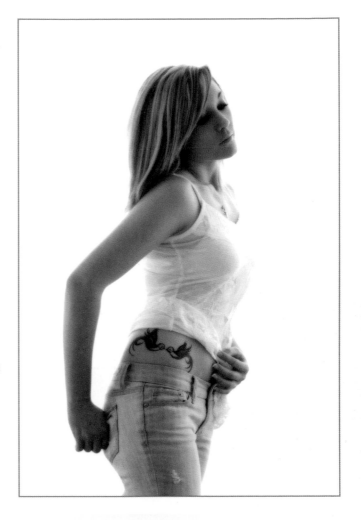

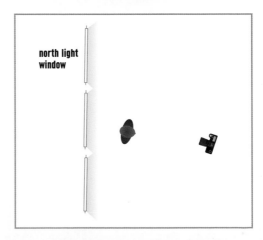

north light
window

Canon 5D Mark II • Canon EF 70–200mm f/2.8L IS USM lens at 120mm • f/5.6, 1/30 second, 400 ISO

24. TRAIN DOOR

CHALLENGE YOURSELF

A few years ago, I gave myself a challenge. For every senior session that took me past the train car, I would stop and create something different. I worked inside, outside, and on top of the car. I would have worked underneath if it weren't for the furry dwellers. I used the train at different times of the day. I learned to use small and large light sources. I sought out different background possibilities, large and small. I found areas for the subjects to sit, stand, lie, lean, and hang among the two cars. There were many angles to follow and colors to use. The challenge was good for me *and* my clients. It assured everyone that they would have something unique. People like variety, and they like to have something they can call their own.

THE SETUP

For this image, I used the doorway of the caboose. I was positioned across from the door, tucked under the ore car. From this angle, I could see into the car. The boards on the floor created depth as they stretched beyond the door. The warm colors on the frame made a nice contrast to the teen's shirt. It was apparent that the light would be good in that area, so I brought in the subject.

The pose was simple; "sit down" was all I said. He sat and leaned against the door. He was too flat and sat too far into the car, so I had him roll on his bottom toward the door. This gave a better angle for his shoulders and brought his face into the light coming from the open western sky. The result was a broad light pattern on his face. The open eastern sky acted as a fill light. No reflectors were needed. I love places like this. Here, I was afforded a little roof overhead and good light, plus a good background. Ah, the simple pleasures of life.

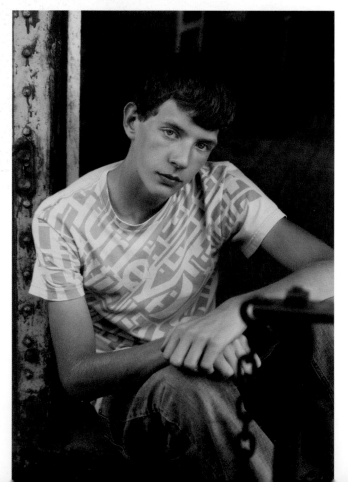

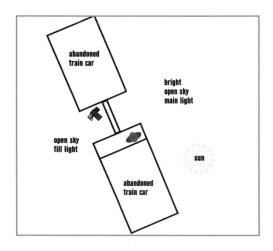

Canon EOS 5D Mark II • Canon EF 70–200mm f/2.8L IS USM lens at 70mm • $^1/_{200}$ second, f/5.6, 400 ISO

25. THOUGHTS AND DREAMS

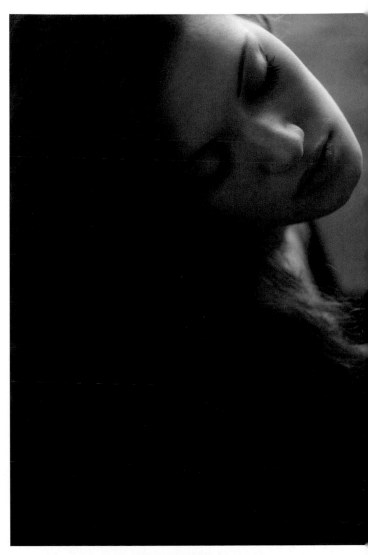

Never underestimate what light does for you. Yes, it is necessary to expose the image, but it can also guide the viewer's eye through the photograph, create depth, tell a story, and portray emotion. That is what this image is about.

A CHALLENGING LOCATION

This portrait was created in a stairwell. There were windows behind the subject. Opposite the windows were dark stairs with a door at the top and bottom of each stair. The light came from the windows. I used a reflector perpendicular to the subject for fill light.

I shot from above so that the landing between the stairwells became the background. It was simple without distractions. It was also dark, which showed a beautiful contrast to the light on her face. One can't help but look at the subject. This light direction could have also been used for a profile portrait.

EMOTION AND EXPRESSION

When you arrive at your location, look around your subject. Maybe the area you've chosen won't allow you to create a portrait in which the subject is looking at the camera, but you may find that a wonderful opportunity exists.

The subject looked down, so there is no direct communication between her and the viewer. This engages the viewer's imagination. He or she will contemplate her expression, which is simultaneously simple and complex.

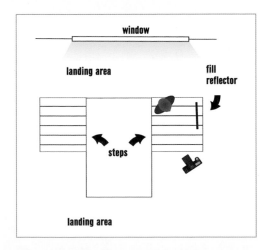

Canon EOS 1Ds Mark II • Canon EF 70–200mm f/2.8L IS USM lens at 125mm • f/4, ¹/₁₀₀ second, 800 ISO

26. DREADLOCKS

Working in the photo industry has allowed me to do some wonderful things. I have been coast to coast and beyond, sharing what I do with other photographic artists. This particular image was created in Florida. The subject was modeling for my class. She had wonderful dreadlocks. She wore a green, soft knit sweater, which harmonized well with her hair and eyes. I had been watching a group of students working with her when I came up with this idea.

Behind the subject was a patch of grass. I knew that with a long lens and a shallow depth of field, I could use the color of the grass without showing its texture. I just needed a high camera angle. I found a garbage can nearby and decided to put it to use. The key to climbing on

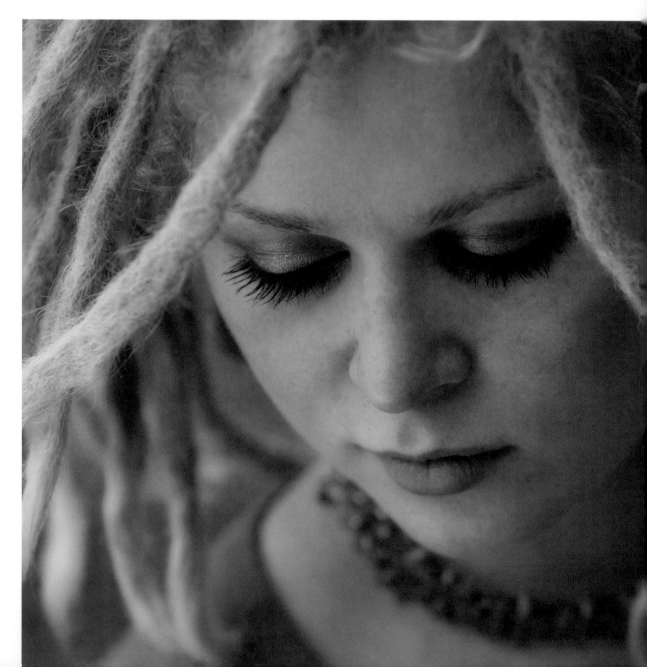

top of a garbage can is to get both feet up on opposite sides of the top rim at the same time. (I found this out after my first attempt to get on it.) Using a high camera angle, I was able to capture what I had envisioned.

CONSIDER THE NUANCES

Portraiture is about making decisions. We must carefully consider the nuances of the subject and scene in front of us and tweak the details to get the image we envision. I might think to myself, "I want a thought-provoking image, so I will want to use a lighting pattern that keeps part of the subject's face in shadow. If I turn her head to achieve that, however, her hair will cover her face in an unflattering way. Instead, I'll use a short light pattern and have her look down and show her face without eye contact." Consider your creative options and make refinements as you go. In this case, I probably should have had her hold this pose but look into the camera as another option. When in doubt, record the image. You can always toss it away later if you don't like it.

LIGHTING AND POSING

The light for this portrait was simple. It was late afternoon and a nearby hotel cast a shadow over the yard. The open sky over the ocean provided the main light. The trees behind and on the shadow side of the subject acted as subtractive light sources and blocked the light from those directions. The only place from which the light could enter the scene was from the side and in front of the subject. All I needed to do was position myself for the background I wanted, then place the subject within that frame. Once the subject was in the correct spot, I had her rotate her body away from the light and her face into the light. With that, I captured the image.

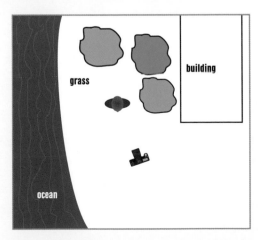

Canon EOS 1Ds Mark II • Canon EF 70–200mm f/2.8L IS USM lens at 200mm • f/5.6, $^{1}/_{400}$ second, 400 ISO

27. "COCAINE LIGHTING"

THE BILLBOARD

Like many of you, I try to make each item in my yard useful for photographs, in addition to using it for its intended purpose. This wall was constructed for my daughter to hit a tennis ball against and also to keep the basketball from rolling too far down the driveway when my son had the ball get away from him. It has also worked well for a few portraits. I don't usually work by this wall in the late afternoon, but as this senior boy and I walked by this location at this particular time, he was wearing a hooded sweatshirt, and I saw this image in my mind.

LIGHTING, POSING, AND COMPOSITION

There was a little raw light skimming over the top of the wall. The raw light was also on the basketball court, bouncing up. I had the subject put his hood up and hang into the scene. I had him lean back and forth until I could get the accent from the raw light to just touch his clothing, while keeping the light from the court on his face. I chose a high camera angle so I could see only the back of the wall and two of the supports.

I broke the rules for this shot. I used what I typically call "cocaine lighting." I let the light shoot up the teen's nose. This lighting is not very flattering—it's best used for someone who is telling a ghost story around the campfire—but it worked here. With the subject's clothing choice and expression, the light made sense and helped tell the story.

I used a reflector for fill, as you can see in the diagram.

If the subject were wearing short sleeves, this approach would not have worked very well. His skin would have been too reflective for the raw light, and the file would have been an unprintable mess.

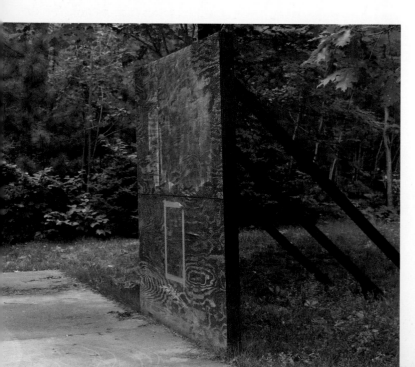

Canon EOS 1Ds Mark II • Canon EF 70–200mm f/2.8L IS USM lens at 80mm • f/4.5, $^1/_{400}$ second, 400 ISO

28. A LITTLE HELP FROM HER FRIENDS

CONNECT WITH FRIENDS AND FAMILY

I don't have employees. If I need an assistant, I recruit the parent or friend of the subject to hold reflectors. Some seniors come along for a friend's session with no intention to book me. After assisting, they often decide to hire me after all. It's not uncommon to have three girls show up two or three times a year—once for their own session, and once more with friends.

THE SETUP

A friend of the subject was perched on top of the retaining wall with a reflector, which stopped the light from coming straight down on the subject. Another friend held the fill reflector. The light was only allowed in from the side illuminated by open sky. The fill reflector was not in its usual place for this shot. The rock wall was in the way. I feathered some fill light from the highlight side, just in front of the subject, to create the desired relationship between shadow and highlight.

We did several poses with this setup. The teen looked most comfortable in this photo, so this is the one I showed the client.

29. BLACK ROCKS

NO PLACE LIKE HOME

I live in the forest area of Northern Michigan. It is cold in the winter and summer goes by quickly, but the beauty of Mother Nature surrounds us always. The background here is what once was the bottom of a raging river. The river continues to carve its way through the rock, but it is now controlled by dams throughout its path. The banks of the river are very high above the water, especially on the west bank. It is because of this high bank that I frequent this location for late-afternoon portraiture. A shadow is cast across the entire river, but the sky to the west still has more power than that from the east. I get a good direction of light from the west. I can look up river or down river and get good light and a background without hot spots.

comparison to her face. You may be wondering how I carry all these reflectors and panels. I don't carry many—usually two. Both are silver on one side and black on the other. One silver is bright (for accent light) and one is softer (for fill). If I don't need one of the reflectors, the opposite side can be used as a gobo.

THE APPROACH

I wanted to create a close-up image but still wanted to see the rock. I had the subject lie against the rock with her head to the east. She turned her face toward the camera, which allowed the light from the western sky to add shape and form to her face. I kept her hands under her body and in shadow to minimize them. The rock she leaned on acted as a gobo. I placed a short black panel just outside the frame to keep the light on her back toned down in

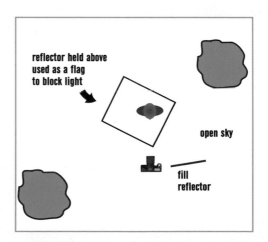

reflector held above used as a flag to block light

open sky

fill reflector

Canon EOS 5D Mark II • Canon EF 70–200mm f/2.8L IS USM lens at 160mm • f/5.6, $^1/_{160}$ second, 400 ISO

30. TRAIN STEP GIRL

TRAIN CAR VARIATION

As you can see, this portrait session took me back to the train car shown earlier. This time, the sky was overcast and I was shooting in the late afternoon. Overcast, cloudy days are said to be best for portraits. It can be true. As far as the background is concerned, it is much easier to work on an overcast day. There is more space to work with that will remain in the same printable tonal range as your subject. Ah, but the subject.

On an overcast day, where is the light coming from? Still above. Yes, you must place the subject in an area that will force the light in one direction to produce flattering light on his or her face. Areas that would work on a bright day will also work when it is overcast.

Because it was late in the afternoon, there was some intensity from the western sky, but not enough to cast raw light everywhere. There was also a great deal of light coming from

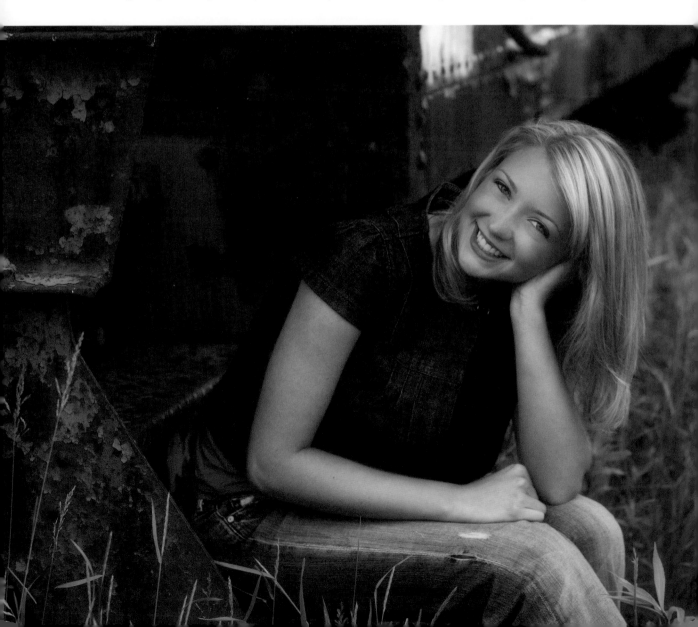

above. I chose not to stop the downlight but work with it instead. By having the subject tip her head and let her long hair hang down, her head became a gobo, blocking the light from the underside of her face. Her long hair also blocked the light from the west. The result was a nice light on the entire mask of the subject's face.

POSING WITH PURPOSE

Because I had the subject tip her head so far to get the right light, I needed a reason for the tilt. I had her bring her hand up so she could lean against it. When you study the image, you'll notice that her arm is not straight up and down. Her hand is behind her cheek and she is not resting her elbow on her leg, it's the underside of her arm. This was done to minimize the size relationship of her hand to her face and to keep her hand from pressing against and distorting her face. Her arm was angled to draw the eye to her face. Having her rest on her triceps rather than her elbow allowed this to happen without looking too awkward. Her face was turned for the light but also directs just a little attention to the other arm. That arm circles back to the leaning arm, and the composition is complete.

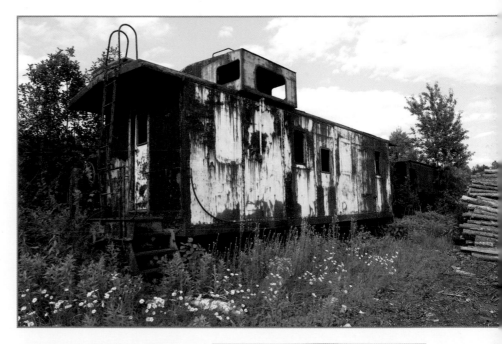

Canon EOS 1Ds Mark II • Canon EF 70–200mm f/2.8L IS USM lens at 85mm • f/4.5, ¹/₃₂₀ second, 400 ISO

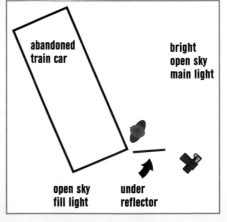

31. PIANO LIGHTING

This image has long been one of my favorites. It will never win any awards, but it marks the point in my career at which I began to free myself not to light my subject's face. It was also the point at which I realized that there are as many stories to be told by the absence of light as there are stories that are told by light itself.

THE LIGHTING

This portrait was created during a demonstration in Cape May, New Jersey. As you can see in the diagram, there were two windows in the room. There was a covered porch outside the windows, which were facing west. The raw light from the sky couldn't reach into the windows under the covered porch, but it still was much more intense than what we see from an open sky. The light skimmed across the subject's back, showing wonderful detail in her shoulder blades and spine. It also outlined her hair, giving it shape against the dark piano. Then I noticed the light on the piano itself. I had the subject slide over on the bench until I could see the light on the piano right behind the profile of her face. There was no light on her face at all. This was a way to elicit a somber mood and create depth at the same time.

The subject's dress was long and flowing, with several layers to it. I used a layer to stop our attention from leaving the image at the end of the piano. In hindsight, I would have done something more comfortable with her arms.

CREATE AN ARRAY OF IMAGES

I have included other images from the same session. These portrait examples show other ways

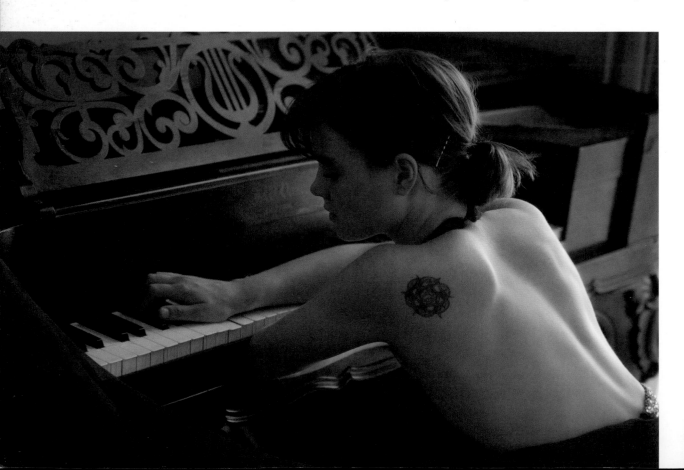

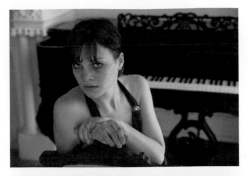

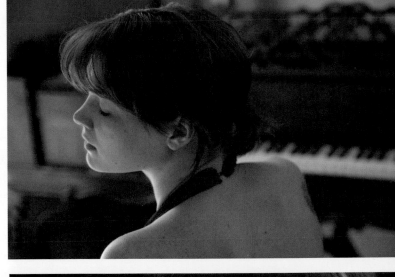

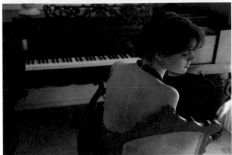

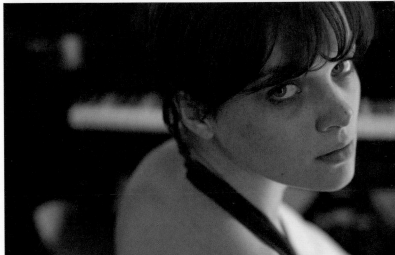

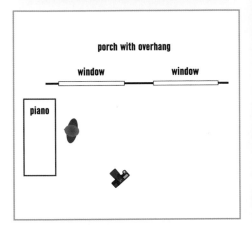

porch with overhang

window　　　　window

piano

Canon EOS 1Ds Mark II • Canon EF
70–200mm f/2.8L IS USM lens at 75mm •
f/4, $^1/_{125}$ second, 1600 ISO

to use the same light source. I could probably have come up with a few more if I wanted to. The point is, while you are in a location with a good background and usable light, look for variety—it's good for the client and for you. Be creative, have a vision, but don't become so entranced with your original concept that you overlook other ideas.

"While you are in a location with a good background and usable light, look for variety—it's good for the client and for you."

32. MOUNTAINEER FOOTBALL PLAYER

BREAKING THE RULES

I have said *not* to go out in the direct sun. Well, for this portrait, I broke my own rules. I had a good reason—well, two good reasons: First, the subject wanted to show off his shades. Where better to do that than in the sun? Second, he was proud of being a football player for his high school team. This background means a lot to him and his family. There are times when the client's story is more important than getting just the right light. Portraiture sometimes requires the same rules that apply when I photograph weddings: First, get something recorded. If there is time, make something better. You can't lollygag and wait for perfection. You may miss everything.

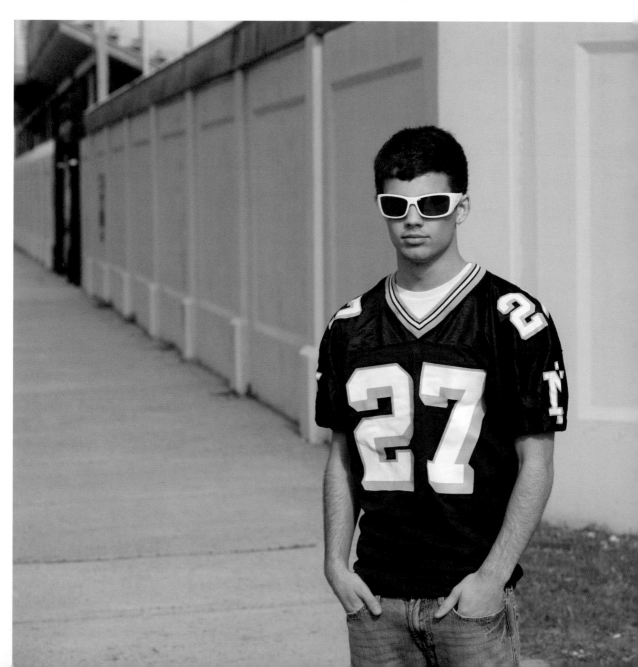

This image was created at mid-morning. The sun was up but still at a pretty good angle to the subject. I was fully ready to expose this image in direct, raw light, but at the last moment a little wisp of cloud made its way between us and the sun. It was still very bright, as you can see by the $\frac{1}{2500}$ shutter speed, but the scene leveled out a bit, allowing the background to be in a good relationship to the subject.

The subject would have been squinting if it weren't for the sunglasses. Because of the direction of the sunlight, I was able to position him

> "I was fully ready to expose this image in direct, raw light, but at the last moment a little wisp of cloud made its way between us and the sun."

fairly square to us and still get the perspective of the stadium wall fading into the distance. The painting of the football player was on an angled wall, which worked out well for this image. The subject, the painting, and the powerful lines of the stadium together form a triangle. Anyone viewing this image will feel that they can reach into the scene. When the photograph doesn't seem to be a flat piece of paper, it becomes more powerful.

PHOTOSHOP ENHANCEMENTS

The client wanted the image to be a combination of color and black & white. I left everything black & white except his jersey and part of the stadium wall. This helped tie the subject to the scene.

Canon EOS 5D Mark II • Canon EF 70–200mm f/2.8L IS USM lens at 75mm • f/5.6, $\frac{1}{2500}$ second, 400 ISO

33. YELLOW FLOWERS

Sometimes, when I am headed to a familiar location, I see a background that is perfect for the client and their outfit. I may see something out of the corner of my eye and hit the brakes. Maybe it's just me, but when I find a location that is just right, I get inspired.

BACKGROUND FIRST

A painter doesn't begin with the subject, then paint the background—and we shouldn't either. You must have a powerful background and good light, and then the subject can exist within the space. When I scout for backgrounds, I also look for the light. The two have become one in my mind's eye. I never disregard cool looking backgrounds in bad light. I just make a mental note to go back at a different time of day.

CREATING THE IMAGE

My subject and I were in a ditch alongside the road. The flowers matched her outfit perfectly. The light was from the western sky, but the direct sunlight was blocked by pilings from the old mine. The trees to the east blocked light from that direction. The result was nice soft light with good direction. I used a gobo to shade the subject's chest to ensure that her face would be the brightest part of the image.

Canon EOS 5D Mark II • Canon EF 70–200mm f/2.8L IS USM lens at 120mm • f/4.0, ¹/₁₂₅ second, 400 ISO

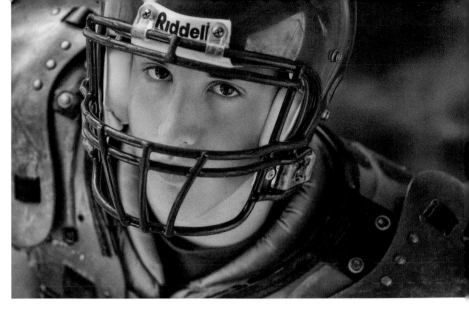

34. FOOTBALL CLOSEUP

IN THE CAMERA ROOM

When I was laying out the footings for my camera room and home, I started with the north wall, which would be the light source for my indoor portraits. I cleared the building site then took out the compass and tried to get a perfect line running east and west. Each time I checked it, I got a different reading. Welcome to Iron Mountain! As it turns out, I was off by a few degrees, which causes issues late in the day during the summer. If I could do it all over again, I would ensure there was at least 12 feet between the end of the window and the east wall. The same would be true on the west side. By having more space from window to wall, you can control the density of your background and the angle at which you use it. As you can see in the diagram, in this case, I needed to block the window to get the lighting I wanted for the subject. I used another background to do this.

Why did we work at such an angle to the window? I wanted to have a great deal of separation from behind. As you can see on the teen's shoulder pads, the light was on his right shoulder. The helmet created an edge and only allowed the light to skim across his face. The length of the window added fill. I used a reflector for a bit more fill and one for more accent on the right side of the image. I left the reflection in his helmet so you can see the placement. One more reflector was used under him and on the highlight side to add fill under his helmet and put a little life in his eyes.

THE POSE AND COMPOSITION

His pose gave us a good angle. His shoulder pads appear in each corner and give our eyes something to follow. Between the corners, the story is told in his eyes.

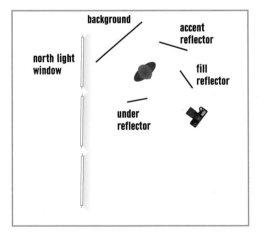

Canon EOS 1Ds Mark II • Canon EF 70–200mm f/2.8L IS USM lens at 120mm • f/4.5, 1/25 second, 400 ISO

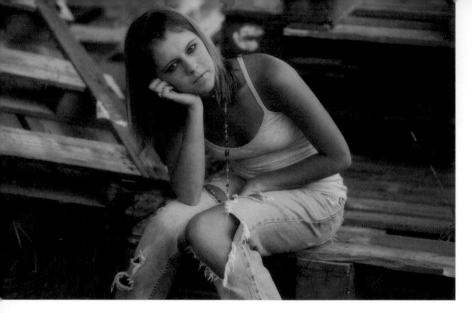

35. BLUE PALLETS

MIDDAY SUN

There are times when we find ourselves out at midday. On those occasions, I immediately seek out overhangs—dense tree cover, bridges, porches—to block the direct light from above. The key is not to get too far under these areas. Too many times I see students right up against the trunk of a tree. Yes, the canopy stopped the downlight, but the good light was not able to get to the subject either. Move out to the edge of the canopy. As long as you can find a background in that area, you will be in good shape.

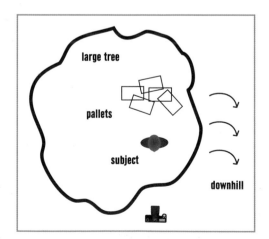

Canon EOS 1Ds Mark II • Canon EF 70–200mm f/2.8L IS USM lens at 153mm • f/4.0, $1/500$ second, 400 ISO

A POP OF COLOR

This pile of pallets caught my eye. The colors in the pile would work well with my subject's clothing. A large tree shaded the pallets and subject. The tree was on a bit of a hill, so the light entered the area at a nice angle to the subject. We could have worked here all morning.

I moved the pallets to create good leading lines to the subject. When looking at a scene, if there is something you don't like, change it. You are responsible for the end result.

THE POWER OF LINES

To pose the subject, I started by turning her body away from the light, with her face turned back toward it. I made diagonals from verticals. Her legs were straight up and down. I had her keep her knees together and bring her feet apart. Diagonal lines lead the viewer, vertical and horizontal lines stop the viewer. I asked the subject to lean forward onto her hand, to the shadow side. This way, her hand is in shadow and does not distract from her face. Her left arm was positioned to complete a compositional circle that leads us back to her face.

36. BEHIND BLACK ROCKS

BACK ON THE RIVER BED

Here we are, back on the river bed. It's amazing how many posing opportunities nature grants us. This time, I chose to look up river to the north. The light was coming from the western sky on this late afternoon. The entire area was in shadow. There was no raw light on the scene.

I liked what the light was doing to the subject's hair, but her hair blocked the main light from her face. The eastern sky took over as the main light and the western sky acted as an accent light.

I positioned myself so I could see the dark rock around the highlight side of her and the light-green bush on the shadow side. This created separation. Always remember that moving a quarter of an inch one way or another may completely change your image.

ABOUT THE POSE

Nature presents great props for your subject to lean on. Just be sure that the person does not lean on the wrong places. Ensure that the flesh is never smashed and distorted. Also, be sure the hands don't appear out of nowhere. If you show a hand, show where it came from; leave a connecting point to the rest of the body.

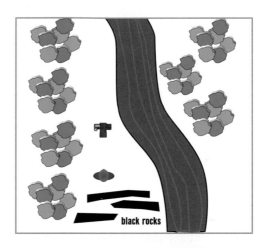

Canon EOS 5D Mark II • Canon EF 70–200mm f/2.8L IS USM lens at 135mm • f/5.6, $^1/_{250}$ second, 400 ISO

37. PROM'S OVER

I see quite a few prom dresses during a senior season. I think any parent would agree it is good to get one more use out of something that cost a fortune. I'll do traditional things with the dresses—some full-length sitting or standing poses mixed in with some close-up images is always good. This time, however, I had something else in mind. I was thinking more of the stress from the prom: the preparations, the cost, and the night itself can be grueling. That is the story I wanted to convey.

THE SETUP

I used the south wall of my camera room and the pillars for the background. I placed the subject by the front pillar and positioned myself so I could see three pillars behind her. I then had her lean forward and lunge toward me until the shadow side of her hair lined up with the

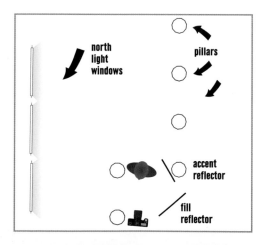

Canon EOS 1Ds Mark II • Canon EF70-200mm f/2.8L IS USM lens at 70mm • ¹/₃₀ second, f/5.6, 400 ISO

"The pose also helped to tell the story. Her legs, showing at an angle, give her a good base and lead the viewer to her face."

highlight of the pillar directly behind her. Now I had a good background and subject relationship. The light was there within the scene. I just needed the subject to turn her face back toward the light.

I used a fill reflector as shown in the diagram and an accent reflector to add to the shape of her legs and dress.

The pose also helped to tell the subject's story. Her legs, showing at an angle, give her a good base and lead the viewer to her face. Her bare feet add to the feel of the image. I was happy with what I saw through the camera, so I recorded the shot. At that point, I thought I was done.

FINISHING OPTIONS

Photoshop allows for infinite artistic options. This portrait was stretched to achieve a better composition and also to help show the loneliness a subject might feel on the day after the prom. I must admit that I didn't think of this during or after the image was created. My friend Michael Timmons suggested the concept. It pays to hang out with talented people. Sometimes their talent rubs off on you.

38. SWEET LIGHT FAMILY PORTRAIT

Scheduling is an important part of my life, as a natural light photographer and a business-person. I try to book seniors or other individuals who are interested in outdoor images for morning sessions. I start outdoors and get as much done as I can before the sun is too high to easily work, then I work in the camera room. I schedule executives and other indoor session clients for midday when the light outdoors is problematic. Midday is also a great time for consultations, image presentations, and production work.

Later in the afternoon, I start photographing seniors again. With these clients, I work indoors first, then we head outdoors as the sun is going down.

A family scheduled for an outdoor session will be photographed in the evening. I give an approximate time when booking the appointment but refine the time as the session draws closer. I confirm a time on the day of the session based on the weather. If it's clear, the session

> "As soon as the sun disappears, I work quickly. This is when the background in a large area will hold together nicely."

will be about fifteen minutes before sunset. This gives us a little "get-to-know-each-other" time before the real push happens. As soon as the sun disappears, I work quickly. This is when the background in a large area will hold together nicely. At this time, the light is from a larger source, allowing for good dimension across an entire family without harsh shadows cast on each other. It is also when even the most sensitive eyes are not affected by the light.

Sweet light times are magical. It's funny. I actually have photographers tell me, "Sure your images are nice. Anyone can do that during sweet light times." I just laugh to myself. They are right, it is an easier time to work. The

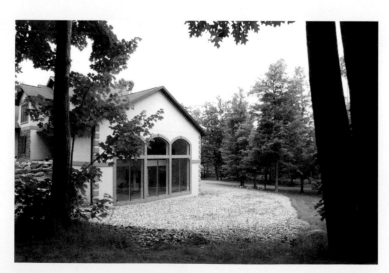

This was my "window," my light source. The family was just to the side of the tree on the right. They faced the camera, which was placed on the left and pointed parallel to the opening.

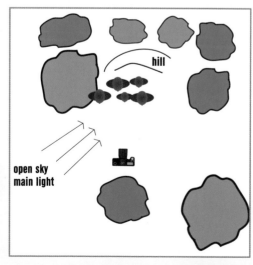

Canon EOS 5D Mark II • Canon EF 70–200mm f/2.8L IS USM lens at 73mm • f/8, 1/25 second, 400 ISO

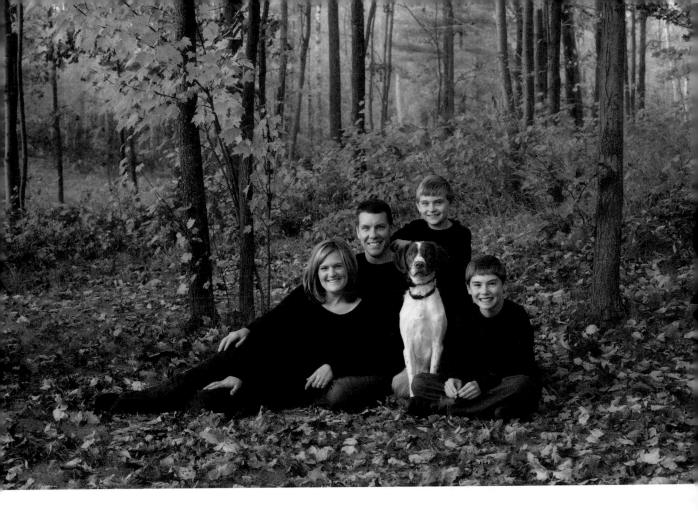

question is, why aren't they taking advantage of that light? Work smarter, not harder. Yes. It can make for a long day, but it makes a better family portrait, and at a time when more families can make it.

A BACKYARD SESSION

For this image, I chose to position the family in a location in my yard facing south. The western sky after sunset served as the main light source. The opening in the trees to the side and in front of the family forced the light to create shape and form on each face. The trees overhead kept light from entering from above. No fill was needed.

The photograph on the facing page shows the view to the right and ahead from the sub-

ject's position. It was a good main light. Remember to sit where your subject will be. Look to where the main light should be. If you don't see a main light there, move on to a different place.

IMAGE DESIGN

I positioned the family in a triangular pose with a little hill behind them for simplicity's sake. Behind the hill is a large meadow area with trees on the far end. That falloff of focus in the trees is what gives this image a sense of depth. When we see an image element that is more out of focus than items closer to the subject, our brain tells us it must be farther away. Depth in an image is your friend. Embrace it.

39. CHEERLEADER

Many athletes come through my studio doors. I do a lot of coaching and supporting of the youth sports in our area. I both appreciate and respect these dedicated folks. Plus, I can relate to them and their lives. I've been in their shoes.

PERSONAL AND PROFESSIONAL GROWTH

For a portrait photographer, the best thing to learn, beyond photography, is human behavior. Psychology ranks right up there and so does drama and speech class. Anything that helps us understand and read into our guests as quickly as possible is gold.

I can relate to people quickly because I have many interests. I am not afraid to try anything, and I love adventure. Listen to different kinds of music. Keep track of sports, even if it's not your thing. Having a little something to throw out there and start a conversation with is important. That being said, don't dig yourself into a hole. If you don't know anything about a subject, say so. It is easy to look like a fool, and fools have smaller portrait orders.

THE SESSION

This cheerleader brought the whole package to the studio—a home jersey, away jersey, jacket,

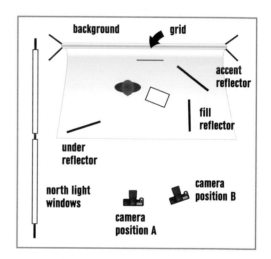

Image 1 (left). Canon EOS 5D Mark II •Canon EF 70–200mm f/2.8L IS USM lens at 85mm • f/5.6, $^1/_{50}$ second, 400 ISO

Image 2 (facing page). Canon EOS 5D Mark II • Canon EF 70–200mm f/2.8L IS USM lens at 140mm • f/5.6, $^1/_{50}$ second, 400 ISO

pom pons, everything. She wanted it all in one image. For the first image (facing page), I put a steel grid against the background and clipped the jersey to it. Then I set a chair in front of the model and draped it with her jacket. She could then stand just to the left of the chair and create a nice triangular composition. I used a focal length of 85mm to show all of her gear.

I don't get into a lot of props, so after making her happy, I got rid of the extra stuff and just focused on her. For our second image (right), I zoomed in to a focal length of 140mm to compress the background and make her more important.

Both images were exposed using the same settings. As you can see in the diagram, the camera was parallel to the windows for the first image. For the second image, the camera was at more of an angle. This way, I could get a more appealing light for the looking-over-the-shoulder pose.

THE BACKDROP

The colors in this background seemed to work well for this outfit. I painted this backdrop many years ago for a dance school shoot. Notice how I painted dark and light areas, knowing I was always

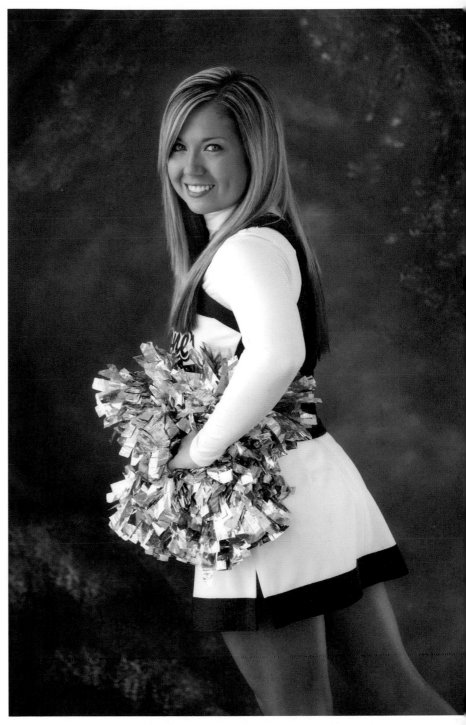

going to light this background from the left. Canvas backdrops are just as important as backgrounds on location. Choose wisely.

40. POINTER SISTERS

AN IMPORTANT EXERCISE

As I have said before, start with a background and good light, then let your subjects enter the scene. This is a good example. The camera remained fairly stationary throughout the entire session. All that changed was the subjects' positions within the frame. Try this: Find a pleasant background with good light. Put your camera on a tripod and compose the image as you see fit. Keep in mind where subjects could best exist. Then put your hands behind your back and verbally instruct your guests to enter the image. Watch through your viewfinder and tell them where to go—backward, forward, right, or left—until the image is complete. Then fine-tune and record your masterpiece. It is a good exercise. I still do it every once in a while. It forces me to think back to front, like a painter.

REPEAT CLIENTS

I have photographed these girls for several years now. It started when I photographed their dance school. I did things a bit differently. I used other dancers as background and foreground material and did composition studies as their dance portraits. The rules were simple: The only dancer that gets to look at me is the main subject. All other dancers are instructed to look down or away depending on where I wanted the viewer's attention to go. The result told more about the essence of dance compared to just standing a girl with her hands on her head in front of a background. I don't photograph that school anymore, but their students still come to me to get this kind of portrait.

These sisters wanted to do something special. They had all learned to stand en pointe. It was quite an accomplishment. I wanted to create a portrait that was classical in nature. The pillars in my camera room seemed like the way to go.

I set my camera for the background I wanted and positioned the subjects in key areas for each different idea. Each girl got her turn to be the main subject. I also recorded them as equals.

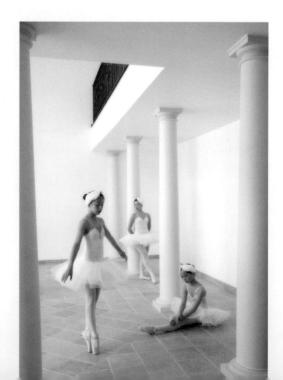

Canon EOS 5D Mark II • Canon EF 16–35mm f/2.8L USM lens at 35mm • f/5.6, 1/50 second, 400 ISO

Along the way, I made sure we did smiling images of each girl and the three of them together. Those were for Grandma. Don't forget about Grandma. Make sure you get some smiles no matter what the story is that you want. Smiles equal sales.

Now, let's move on to the lighting. The girl closest to the camera was going to have more of a defined shadow than the girls farther away. This is logical. The girls farther away had more length of windows, so the light would wrap around their faces. I liked and embraced the idea that the girls farther away were going to have softer light, softer focus, and less communication with the viewer. It was all part of the plan.

If you look at the supporting image (facing page), you can see that there were wrought-iron railings in the balcony area of the space. The the main image (which I used for competition) has the black railings removed. The client didn't mind them, but I felt they were a distraction.

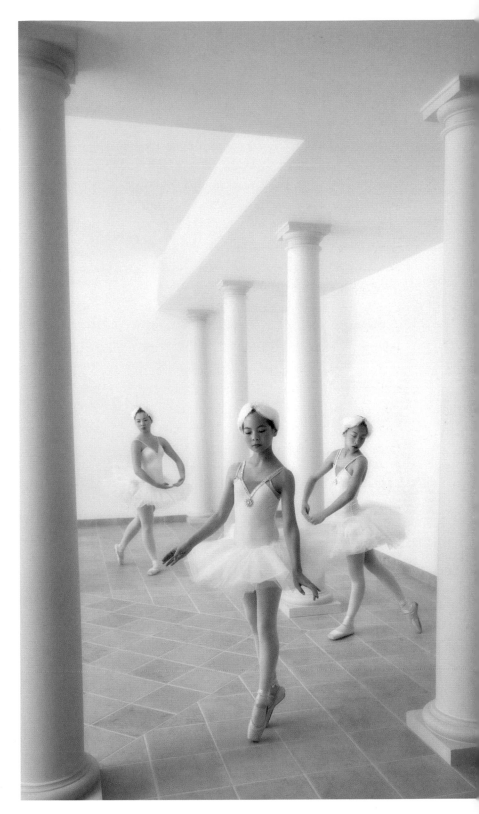

41. DIAGONAL DOOR TRIM

A great deal of thought went into creating this simple but interesting image. I'll begin with the light. The open sky to the north provided the main light. It evenly lit the entire building and the subject. It was late afternoon, and the sun was in the western sky, just high enough to skim over the building. As you can see in the diagram, the raw light actually hit the ground right near my camera. I saw that the light was hitting the model's hair and shoulders as she leaned against the black door. I had her step backward along the building until I saw just a hint of the raw light skimming the top of her head. It was just enough to give a bit of separation without blowing out her hair.

A HAPPY ACCIDENT

Now, for the happy accident that the light forced me into: Originally, I had planned to make the black door with the white door behind it the entire background. Because the light forced me to move and rethink, I saw the repetition of the diagonal lines on the doors. Way cool! The black door acted as a foreground without causing distractions. The diagonal door trim next to the subject keeps the viewer focused on the scene. The diagonal trim beyond her leads the eye back to her and helps create depth in the image. I also liked the old concrete on the ground behind the gas can. The simple slabs bring the viewer's eye past the subject, deep into the image. The eye then stops at the vertical strip of blocks at the edge of the image. Suddenly, we bounce back to the subject with the help of the diagonal trim. The composi-

"The open sky to the north provided the main light. It evenly lit the entire building and the subject."

tion is simultaneously simple and complex. It's amazing how the brain sees things.

A NATURAL-LOOKING POSE

There was an eyelet in the door that gave the subject something to do with her right hand. I wanted a strong lean of her body to contrast the diagonal trim. Together, they form a V shape. Her head was tipped parallel with the trim on both doors. This helped build a relationship between the subject and background. I had her turn her hips and cross her legs. With her thumb in her pocket, we were ready to record.

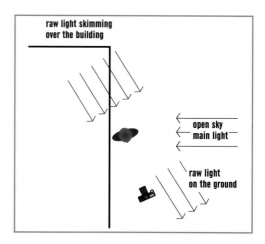

Canon EOS 5D Mark II • Canon EF 70–200mm f/2.8L IS USM lens at 70mm • f/5.6, $^1/_{160}$ second, 400 ISO

42. TRAIN HANG

SAFETY FIRST

Here is the same senior shown in section 41, photographed a few moments later. I walked past the building she was leaning against to the train cars that were parked there. *Note:* These cars are not on railroad tracks. They are stored in an abandoned train yard. The track is disconnected and leads nowhere. Never photograph by active trains or work on live tracks.

AN APPEALING LOCATION

I did like the repetition of the cars. I liked the warm colors, and the light was nice. The main light was actually the open sky to the east of the subject. The building kept light from entering too much from behind, and it reflected some raw light that produced an accent in her hair. You can also see it on her sleeve by her face. The train cars shadowed the area but, as you can see, a few little strips of raw light made their way between the cars. Since the light was feathering across the long grass, I figured it wasn't going to cause any problems. The light showed the mask of her face, and I let her smile and be happy.

For the pose, I had her just stand by the car. She turned diagonal to me. I had her put her weight on her back foot, then she reached up and grabbed the handle on the car. It seemed more comfortable and looked more slimming to have her cross her left leg over her right. Her right arm was initially too far back. I had her move it forward until I could see a good connecting point without making her look wide across the middle. A good tip of the head and a little work on her hair, and all was complete.

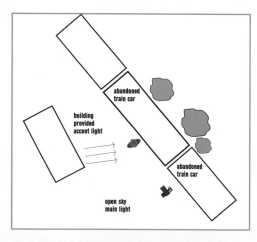

Canon EOS 5D Mark II • Canon EF 70–200mm f/2.8L IS USM lens at 85mm • f/5.6, 1/100 second, 400 ISO

43. GRASSY BEACH

SWEET LIGHT REVISITED

Here's another example of sweet light. The sun was almost down, and some trees on the horizon blocked most of the direct light.

A BEAUTIFUL BACKGROUND

Three steps out of the parking lot, I saw this background. The light was nice in the immediate area, so I stopped to play. I noticed the path in the sand with tall grass on either side. I sat the model down on the edge of the path, so I could see the path beyond her body. This created a sense of dimension.

I liked how the grass shared characteristics with the subject's hair. This helped tie her to the background. I posed her so that her hair would mimic the feeling of the grass behind her.

I couldn't change where the sun was setting, so I changed the subject's relationship to the light. In this pose, her body was turned away from the light, with her face turned back toward it. Her body was dark, and her face was light. Always use the light to motivate people to look where you want them to look.

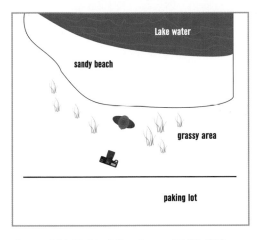

Canon EOS 5D Mark II • Canon EF 70–200mm f/2.8L IS USM lens at 78mm • f/5.6, $^1/_{30}$ second, 800 ISO

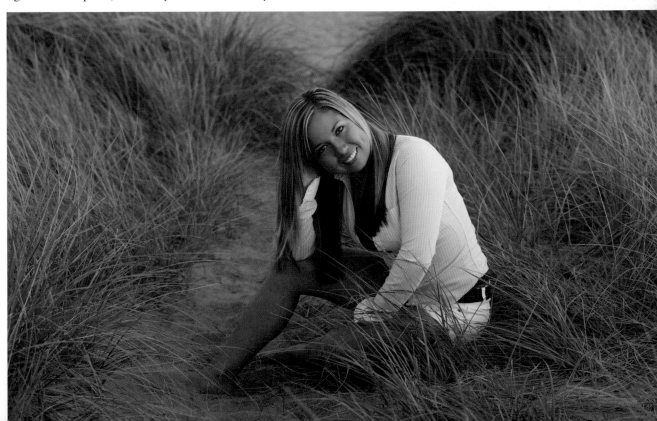

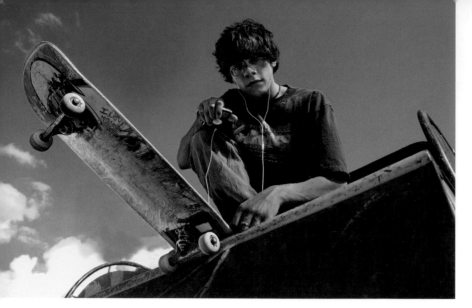

44. SKATER BOY SKY

HAVE FUN

It's important to play. Get to know your subject and let them be themselves. If I have a musician in my studio, I ask them to play. Athletes show off their stuff. It makes them comfortable and makes for more meaningful images and bigger sales. Learn who your subjects are, then use what you know about artistic portraiture to show your viewers who your subjects really are.

During this particular session, I watched the subject launch himself onto the tower. I did some action shots, but a controlled portrait was what I was after (and what his mom wanted). When I saw him on the tower, I thought, "What a cool viewpoint!" I had him look over the edge. He hooked the board on the edge of the wall, and I saw the story I wanted.

NATURAL LIGHT

The tower was positioned just right for where the sun was. It was late afternoon and the shadows were falling hard to camera left. I couldn't put a reflector under the teen because it would show in his glasses, so I placed a silver reflector off to the east. This lit the bottom of his board and added a little accent on his right cheek. The

> "If I have a musician in my studio, I ask them to play. Athletes show off their stuff. It makes them comfortable . . ."

rest of the light that brought out his face came from a large ramp below the tower. I was facing southeast, so the sky looks nice and blue.

POSTPRODUCTION

I used Nik Software's Tonal Contrast filter to add some punch to the skateboard and a little to his face.

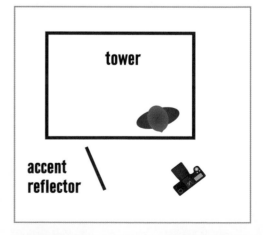

Canon EOS 1Ds Mark II • Canon EF 16–35mm f/2.8L USM lens at 28mm • f/7.1, $^1/_{160}$ second, 100 ISO

45. LAKE SWIMMER

My niece was on her high school swim team. She thought it might be nice to have images made with her in the water. This location was perfect. There is a dock to stand on. I didn't have to get wet and was able to look down on her a little, which allowed me to show the lake around her. From this angle, there were no distractions from trees, weeds, or horizon lines.

Canon EOS 5D Mark II • Canon EF 70–200mm f/2.8L IS USM lens at 28mm • f/3.5, ¹/₄₀ second, 1600 ISO

THE POSE

I had the subject stand with equal weight on both feet, and she crossed her arms. I centered her to show power. To ensure the pose worked in the light we had, I turned her slightly toward the lake to shadow her body and had her turn her face back toward the light. A stern expression seemed to suit the pose.

The island over her left shoulder and the trees on the left make a triangle to her. With the water equally on both sides, there is symmetry.

WHY NOT USE STROBES?

If I used strobes, I could work at any time of day—but it wouldn't be the same. First, the wind usually calms down in the evening, and the water's surface becomes glass-like. Second, no strobe could light the subject and the trees in the background to keep exposure detail.

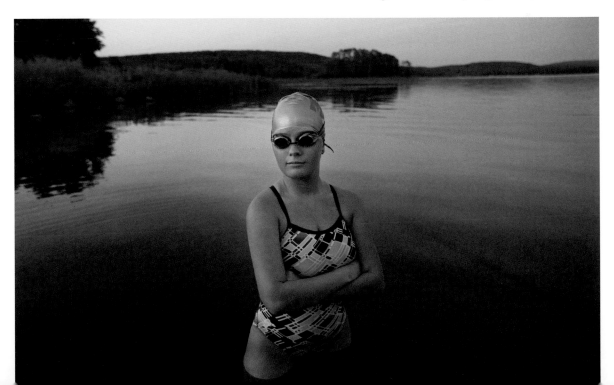

46. BLACK ORE

LET THEM DO WHAT THEY DO

I decided to add this image to the book at the last minute. It's a nice portrait, and the light and background are good, but the example I wanted to share is the subject. This is the skater boy shown in an earlier section. It was later in his session, twenty miles away from the skate park. This is why I don't incorporate specific poses. I told him to be low. This is what he did. He looks strikingly like the pose in his tower image. Why? Because it is him. It is what he does. Watch your subjects. Let them do what they do, then tweak the pose to be more photographically correct. The more a person looks like themselves, the better your images will be received by them and their family.

LIGHTING

Let's move on to the light. I chose this background for the color and because it cast a shadow over itself. The sun was still up, but not by much. There was raw light on the ground in front of the pile of ore. I had the teen walk into the scene until the pile blocked the raw light from hitting him. Then I had him squat down. He was on the very edge of the raw light; this presented a clean, crisp, dimensional view of his features. I did need an accent reflector (it was placed as shown in the top view diagram) to help separate him from the black ore. As you can see in the side view diagram, the pile of ore defined the edge of the light source. Notice the nice texture in the guy's hair, clothing, and skin. If he were to go farther into the shadow of the ore, the light would flatten out and eventually come from the other direction. I could have had him go to the back of the pile, as shown in the side view diagram. The light would have been from the east, with less contrast, and the background would have been different, but it would have worked. An image with the subject positioned in the middle of the pile would not work as well. The light would have had the same flat, contaminated look that you would find if too deep under the canopy of a tree. The moral of the story is, live on the edge.

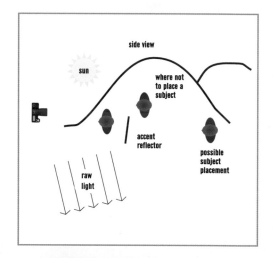

Canon EOS 1Ds Mark II • Canon EF 70–200mm f/2.8L IS USM lens at 90mm • f/4, ¹/₃₂₀ second, 400 ISO

47. WATERCOLOR GIRLS

A DISTINCTIVE LOOK

A small part of me misses film, but when I look at all the tools at our disposal now, the feeling goes away quickly. I love the fact that we can print a photographic image on watercolor paper. We can enjoy the magic of the textures and the softness that the medium has to offer. I love it when little girls attired in pastels walk through my doors. I instantly know at least one direction I am going to go.

I tend to keep light colors on light backgrounds. This way, the subject's face is in contrast with the clothing and background, and, as such, it will draw the eye. However, we still need to light the face correctly.

For this image, I used my north light camera room. I positioned the subjects against a pillar, as shown in the diagram. The pillar allowed me to use the edge of the light coming from the window. The older girl became the base for the image. I turned her away from the light but had her turn her face back toward me. This gave an appropriate broad light. The younger girl just snuggled into her sister. When they started holding each other, I quickly repositioned their arms to form a circle with their faces. This circle will hold the viewer's eye. Because the younger

girl was posed toward her sister, the light from the window produced a short light pattern on her face. The broad light allowed for the somber eye contact of the older girl. Because short light is usually a happy light pattern, I had the little sister look away from the camera to avoid eye contact with the audience. Now between the light patterns and the posing, the soft emotion was portrayed.

POSTPRODUCTION

The post-process work on this image was done with layers of white backgrounds and layer masks. I painted different opacities of the white underlying backgrounds to enhance the existing highlights. Then I vignetted the image until it faded to white. This type of post-process work is meant for watercolor printing.

"I tend to keep light colors on light backgrounds. This way, the face is in contrast with the clothing and background, and will draw the eye."

Canon EOS 1Ds Mark II • Canon EF 70–200mm f/2.8L IS USM lens at 75mm • f/5.6, 1/$_{50}$ second, 400 ISO

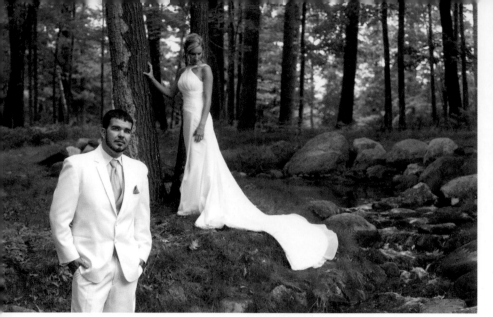
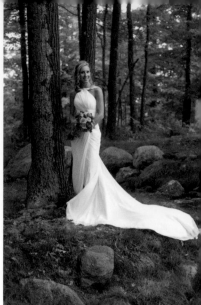

48. WEDDING RAPIDS

Many years ago, at a photography convention, I overheard other attendees conversing. They were searching for a program to attend and looked at the sign outside the door of the room I was waiting to enter. It was a wedding program. One attendee said, "Oh, it's a wedding program. I don't do weddings. I'm not going in." It's a shame that they missed it. I learned portraiture from a wedding photographer. I discovered techniques I could use when photographing seniors, families, or chasing kids around the yard. It does not matter if you photograph weddings, rock stars, or rocks. Light is light and composition is composition. There is much to learn from everyone.

ON THE COURSE

This bride and groom wanted outdoor portraits. We borrowed a couple of golf carts and hit the links. Armed with photo gear instead of clubs, we found a few nice backgrounds with nice light. This was one of them.

As shown in the diagram, there was an open area over the fairway to my right. Trees lined the left side of the image as well as the entire area behind the couple. The bride was standing by a tall oak tree. Its canopy reduced the light from above but allowed it to enter from the open sky. Due to the layout of the area, light could only enter the scene from my right and behind me. We had a stream and woods, good light, and a bridal couple. Life was good.

Canon EOS 5D Mark II, Canon EF 70–200mm f/2.8L IS USM lens. Exposure: f/5.6, ¹/₅₀, 400 ISO. Focal length at 75mm.

TIME IS OF THE ESSENCE

On a wedding day, time is of the essence. Since I found a good place to play, I planned to do multiple shots here. I started with the couple together. I leaned the groom against the tree and had the bride lean into him. The time-consuming part was her dress. Since it was already in a good place, I left it there. I pulled the groom down to the foreground and created another image without having to reposition the dress. Then, I had the groom step out and I photographed the bride. This time, I had to make a minor change to the position of the dress.

These images were made possible because of natural light. The source was large enough that I could move the subjects around and still have the same direction and exposure of light from person to person and image to image.

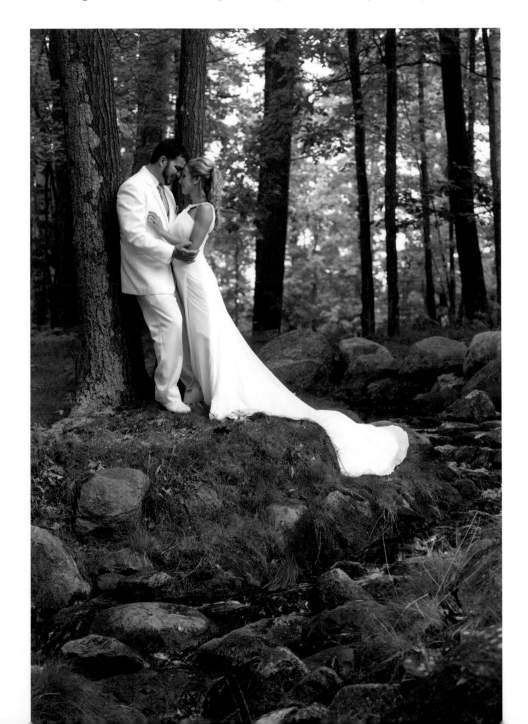

49. THE BROWN LOUNGE

FURNITURE AS PROPS

A few years ago, I was wasting time in a furniture store while the salesperson talked to my wife about new couches. Out of the corner of my eye, I saw this chaise lounge. I noticed that the textures in the seat repeated in a diagonal pattern. I saw the nice soft sweep of the head of the lounge. I thought to myself, "If you noticed this lounge, amidst all of the other furniture, it must have good potential for a posing prop." We bought it. I was right—it was a great prop once it was heaved into place. I didn't know how heavy it was until it was delivered, and now it is a permanent fixture in my house.

THE SETUP

For this portrait, I turned the lounge diagonally to the backdrop with the head facing away from the light. I chose a brown background to match the lounge and selected the dark shirt for the senior. I had the entire scene set up before the teen entered the room. I even positioned the reflectors. I knew where I was going to need the light.

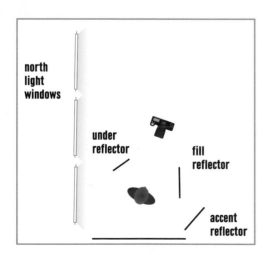

Canon EOS 5D Mark II • Canon EF 70–200mm f/2.8L IS USM lens at 135mm • f/5.6, $^1/_{80}$ second, 400 ISO

When the teen came into the room, all I did was ask her to sit down facing me and lean over the lounge. I fixed her hair to show its length and repositioned her hands slightly, but there wasn't much to do. Notice how the light on her face is up against the dark shape on the background and the dark side of her face is up against a lighter shape? This was planned in advance. Before the senior came out of the dressing room, I looked at the head of the lounge and saw good light there. I knew that same good light would fall on the subject. I use this approach often. For example, if I am to photograph a child who can't stand still, I place a chair where I want it to establish the desired light and background relationship. Then I have the child sit on the chair or stand by it. Even if they only stay for a moment, at least they are in the right spot.

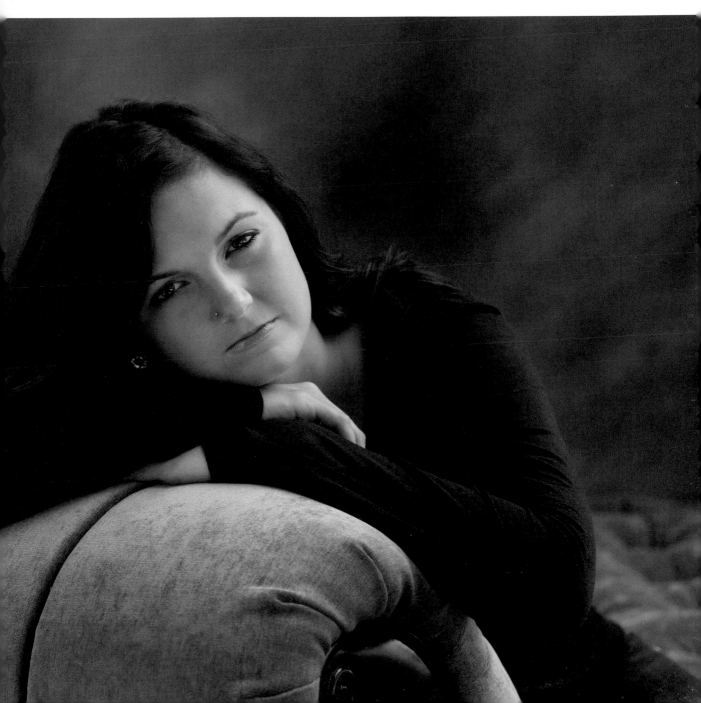

50. JACK AND JILL

JUST LET THE SUBJECTS EXIST

It was frustrating to create portraits of my kids. Seriously. When I took photographs of everyone else's children, things worked out just fine, but when my kids were in front of my lens, nothing seemed to go right. I guess it just seemed like playtime to them. The last thing they wanted was to sit still for a portrait. I always told other photographers, "Find a background with good light and let the subjects exist." After a few attempts, I started to listen to myself.

A MEANINGFUL LOCATION

We spent a lot of time at an old cabin as kids. When the weather started getting cold, the water was turned off to the cabin. If we spent any time at the cabin after that, we had to get water from this pump. I remember making many trips with water sloshing out of the bucket. It wasn't really an assigned chore; I just liked doing it.

The pump is still there today. It has meaning to me and my family, so I decided to use it for this portrait.

Next to the pump is an old log cabin. The yard is lined with trees, and there are deep wooded areas. In the late afternoon, the cabin casts a shadow over the pump area. The trees to the north and west block light from falling on the background. The open sky to the east provides the only light that can reach the pump. It is forced into the scene perfectly for a portrait.

I didn't want the kids to know I was trying to take pictures, so I didn't take my camera out of the bag until I showed them how to use the pump. Once they started having fun, I pulled

> "There was a little red in the background, but it wasn't enough to draw attention, so I enhanced it . . ."

the camera out, set it on the tripod, and started recording. I felt as though I had won.

POSTPRODUCTION

It was early fall when I created this image. The leaves were just starting to turn. There was a little red in the background, but it wasn't enough to draw attention, so I enhanced it and added a bit more red to harmonize with the pump. I also added some yellow in the top center of the image to contrast the blue outfits and help create a sense of depth. I added a little orange to the leaves behind my boy and to one leaf in front of the kids to keep the viewer's eye bouncing back and forth in the image. This image is still hanging in our home, partly as a great memory of our children and partly as a trophy for finally winning the portrait war.

Kodak 14n • Nikon 80–200mm f/2.8 lens at 100mm • f/5.6, $\frac{1}{200}$ second, 400 ISO

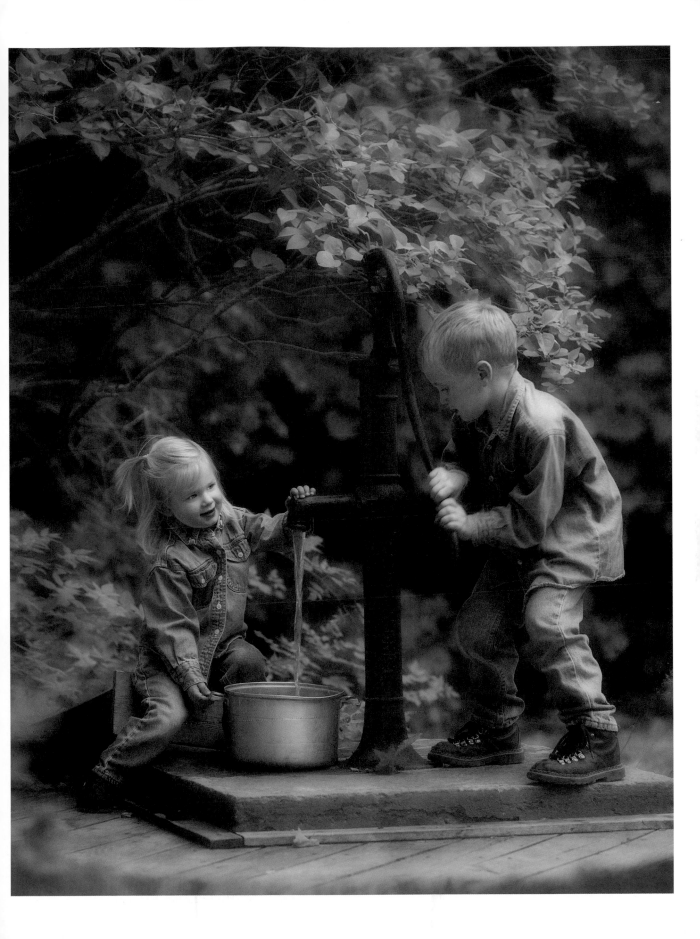

51. PAPA BEAR

LIGHTING THE PROFILE

One of the lighting patterns I see most misused in natural light is profile light. The problem seems to be particularly prevalent with brides. We have a bride in a white dress with lace and beadwork, and she is holding flowers. The photographer poses her in the middle of the window and has her look out dreamily over the world. He can see her face light up and see the profile; he thinks all is good. When the files are processed, the flowers are blown out, the dress has no detail, and the light outlining the bride's face is glowing. A strange orange line follows the edge of the glow. What happened? Was the exposure incorrect? It may have been, but this problem would have occurred even if the image were exposed correctly.

Light travels in a straight line. If light is directed straight at a reflective surface, it will bounce off and return to the source. This becomes a spectral light. In terms of ones and zeros, which is what digital files are, how much information do you think is in a spectral highlight? The answer is zero. So, how do we create a profile light and still hold detail?

THE APPROACH

I wanted a profile of this new father holding his son. I placed a background in the normal location on the east wall. I positioned another background along the windows to act as a gobo. The subject sat at the edge of the gobo on the same side of the window as the camera. (If he looked straight forward, he would have been looking at the light-blocking device.)

> "Light travels in a straight line. If light is directed straight at a reflective surface it will bounce off and return to the source. This becomes a spectral light."

This way, the light was forced from behind the subject in relationship to where the camera was. The light skimmed across the subject and did not blow out any detail. Notice how you can see the pores in his skin and the soft hair on the newborn's head. If the subjects were in the middle of the window, none of that would be showing. In my studio, the other windows provide fill light. In other locations, the wall between windows will work as a gobo. Just remember to place the subject on the same side of the window as you are on. You will create a much better profile light and your subjects (and vendors, in the case of bridal portraits) will like you a whole lot more.

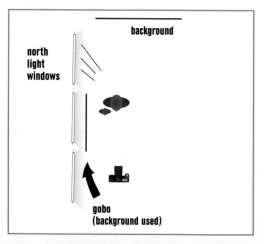

Canon EOS 5D Mark II • Canon EF 70–200mm f/2.8L IS USM lens at 153mm • f/7.1, $^1/_{60}$ second, 400 ISO

52. TRAIN WHEEL

POSE WITHIN THE LIGHT

When the sun is your main light source, you must move the subject and yourself in relationship to the light to get flattering results. For this reason, I often say "Pose within the light."

This image was made using a component of the train car seen elsewhere in this book. The subject was posed between the train cars and stood on the hitch. The wheel she is leaning on has, I assume, something to do with the connections for the cars. It made for a good prop.

WHY THE POSE WORKS

Using this leaning pose allowed a few good things to happen. First, her body formed a great leading line to her face. Second, the pose drew attention to her long hair. Third, the horizontal image was a nice counterpoint to the predominantly vertical images I captured during the session. Fourth, the pose made good use of light, which was coming from an angle that would have been too low with a more upright pose.

This image was created in the late afternoon under overcast skies. The light was entering equally from both sides of the cars, so I used this pose to create the direction of light that we see. With her body leaning this much, her head tilt looks comfortable. The light from above and to the east illuminated half of her face. Her head blocked the light from the rest of her face.

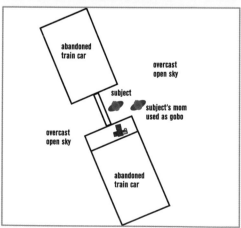

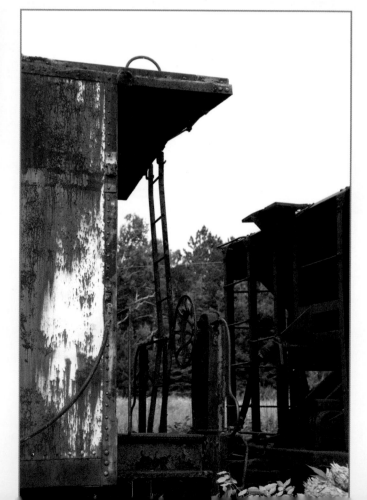

Canon EOS 1Ds Mark II • Canon EF 70–200mm f/2.8L IS USM lens at 85mm • f/5.6, $^1/_{160}$ second, 400 ISO

Since the caboose was only 2 feet away, no light came from in front of the subject's face. Therefore, it appears as if a split light pattern was used. Okay, I *did* say the light was equal from both sides of the car—but I used the subject's mother as a gobo. She was standing just outside of the frame to our right. She didn't know it, but in her attempt to watch the session from a close distance, she was also helping my lighting. Anything can block light. Use what is available to you.

Timing is everything. Again, this image was made late in the day, under overcast skies. At midday, the sunlight entering this area would have been too harsh. The background would have so much contrast from highlight to shadow that photographic paper would not be able

to hold the tonal range. The subject would have no detail in her hair or skin. Sure, we are natural light photographers, but that doesn't mean that *any* natural light will work for the portrait we have in mind. I have heard people say, "You're a professional. You should be able to work anywhere." That may be true, but my thinking is that a professional should also know when something will or won't work. Not every time/ location combination will yield good results. That being said, if a client *needs* to have a portrait made in a specific area and the light is bad, I can opt to use strobes to get the job done.

53. ON THE ROCKS

THE OLD ORE MINE

It's great to find locations that provide good shade for a long period of time. This is the case with the pilings from the old ore mine. The pile of jagged rock is very tall and fairly steep. The stretch of debris I use runs north and south. As the sun reaches the western sky, a nice shadow covers the bottom of the hill and the surrounding area. It is a nice place to work in the late afternoon, and the good lighting conditions last a long time. As you can see in the side view diagram, the hill of rocks is in complete shadow and makes an evenly illuminated background. Light cannot come from the rocks to the right or from the trees behind the subject, so that means the light can only come from the north, the east, or above. I had to keep this fact in mind when deciding how the subject should pose within the light.

I chose to use the light from above the subject's face. Because of the pose, she was able to tilt her head dramatically and still look comfortable. Her hanging hair blocked the soft light from the east. The ground acted as a subtractive light source too. Light fell onto her face from above and from behind the camera with the same wraparound quality I'd expect in my camera room. The wall of light was just rotated on its axis to match the axis of her head tilt.

THE PERKS OF NATURAL LIGHT

If you study the entire body, you will notice the light on the teen's leg was coming from the east. It did a great job of creating shape. This tells me that we could have posed her to use

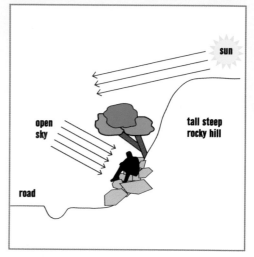

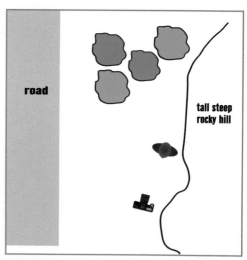

Canon EOS 1Ds Mark II • Canon EF 70–200mm f/2.8L IS USM lens at 70mm • f/5.6, $^1/_{320}$ second, 400 ISO

light from that direction as well. The advantage of understanding and using natural light is that you can use body positions to relate to different light sources within the same image—without carrying multiple sets of strobes and modifiers all over the countryside. Could you imagine trying to light this with strobes? The locale is too rugged to use light stands. You would need several assistants to hold your lights.

"Could you imagine trying to light this with strobes? The locale is too rugged to use light stands. You would need several assistants to hold your lights."

54. LAKE ANTOINE AT SUNDOWN

TO THE BEACH!

Once again, we find ourselves at the beach. When is the best time to shoot? You should know by now that it's late evening or early morning. Since most teenage girls would rather not have their portraits done at 4:30AM, evening seemed like the right time for this session. This shot was made after the sun disappeared behind the trees on the horizon. When the raw light was completely gone, I started working. I will say this: Using the lake shores inland allows for much more time to work on the beach, as compared to working on the ocean shores. When I teach on the beaches of California, once the sun melts into the water, it gets dark fast. Inland, where I work most of the time, the trees and topography of the surroundings block the raw light from the sun earlier; this allows me to begin working before the sun has actually set. What an advantage! The same rule applies to the East Coast during our morning sessions. When there is nothing but water in the way of the sun, the raw light appears quickly. Just be aware of this so you don't get caught off guard.

CLOTHING

I went through the girl's wardrobe before the session began and found this dress. She was scheduled for an extended session, and the beach was to be our last stop. I immediately knew this was to be her final clothing change. The cool color of the water was sure to work well with the blue colors in the dress.

COMPOSITION AND POSE

The beach runs nearly north and south. I positioned the teen so that I could see some beach all around her—and some water to harmonize with the dress. Her pose parallels the water line and produces nice leading lines that direct the viewer's gaze to her face. For modesty's sake, I had her hold her dress from under her knees. This gave her something to do with her hands without ruining the leading lines. It also helped give her shape. Her head was tipped to the left to create balance in the pose and allow the light to form a Rembrandt pattern on the teen's face. If her face were to follow me as I moved closer to the water and showed the beach as a background, we'd have had a short light pattern. In that same location, if she turned her head to the shore, the pattern would be broad lighting. You can often take advantage of many options just by having the subject turn their head.

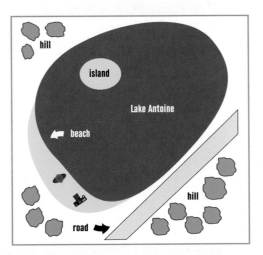

Canon EOS 1Ds Mark II • Canon EF 70–200mm f/2.8L IS USM lens at 140mm • f/4.5, $^1/_{160}$ second, 400 ISO

55. PURPLE DITCH

HITTING THE BRAKES

This was another occasion where I saw something cool while driving and had to hit the brakes. In the ditch, not 10 feet away from 60MPH traffic, there were tall, purple flowers. We had to go play.

The trees along the road shadowed the area from the early-evening sun. The most intense light came from the open sky to the south. Some light came from the east, but it was not as powerful, and the result was a wraparound lighting effect. I added a black panel just out of view to the subject's left. This gave a bit more shadow on the left side of her face. Another reflector was added from underneath and on her highlight side to add a little light under her eyes.

I enjoyed the transparent look of the flowers and the opaque quality of the stems. The look of the dark stems is repeated in the trees farther in the background. This helped create a sense of depth. The flowers fading out of focus also enhanced the feeling of a third dimension.

THE POSE

The pose was simple. I saw a triangle of light yellow in the scene behind her, so I mimicked it with her pose. The photo below shows what was going through my mind as far as relating the subject to the background. The opposing corners also matched. These were ingredients for good balance. Everything in your image should have a purpose.

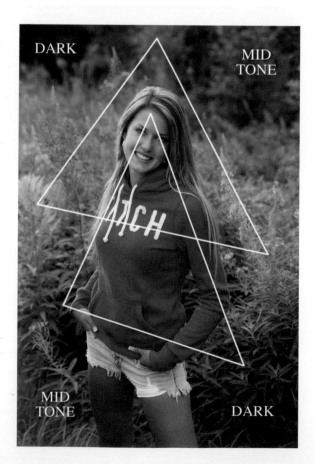

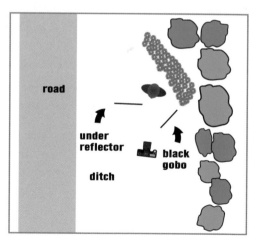

Canon EOS 5D Mark II • Canon EF 70–200mm f/2.8L IS USM lens at 95mm • f/5.6, $^1/_{200}$ second, 400 ISO

56. FOUND ON THE DOORSTEP

EARLY MORNING SESSION

In the summer, the sun rises over the trees early. By 8:30AM, the only places in shadow are on the west side of buildings and under large overhangs.

Outdoor sets should be in good quality light for as much of the day as possible. My photo shack has a door and window on both the east and west ends of the structure—the west for the morning sessions and the east for afternoon shoots.

THE POSE

I had my guest sit on the doorstep on the west side. She naturally leaned forward on her legs.

I had her bring her feet apart to create diagonal lines.

LIGHTING

Trees to the south and west blocked much of the light from the open sky. The main light was coming from the larger clearing and the open north sky. As the subject leaned forward, her face entered the light. Note that her face and hand are brighter than her shoulder. Her shoulder was naturally toned down because the wall blocked the north light. I positioned myself to get a look into the shack and achieve a good pattern of light on her face without contorting her too much. I used a reflector under the subject on the highlight side to brighten her eyes.

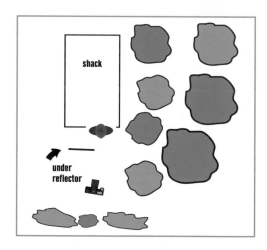

Canon EOS 5D Mark II • Canon EF 70–200mm f/2.8L IS USM lens at 78mm • f/5.6, $^1/_{200}$ second, 400 ISO

FINDING BEAUTIFUL LIGHT

The next time you are traveling by air, watch people. Most airports have massive windows and long hallways that create a great combination of light and background. People are naturally walking through the areas. When something catches your eye, chances are, it's because the person walked into an area of great light. Note where the light was coming from at that moment. The hope is that you learn from this discovery and duplicate the effect on assignment.

SEIZE THE MOMENT

This image was created during one of my class demonstrations. The subject was one of my students, and not the person I was photographing. As I talked to the class, I noticed the beautiful light on his face and I had to go off on a small tangent.

As you can see in the diagram, the subject was standing near a pillar on the second story of a covered hallway. The open-air courtyard allowed light to come in and bounce off the wall behind the subject. The light from the open sky

from the southwest could only get to him from behind as well because the pillar blocked the light from directly to the side of him. The end result was a very nice double accent light. I just had to record it.

So my question to you is, What time of day was it? Would this image work right here at a different time of day?

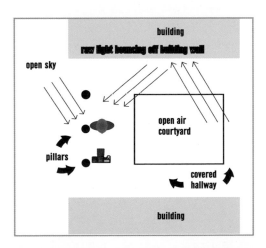

Canon EOS 5D Mark II • Canon EF 70–200mm f/2.8L IS USM lens at 160mm • f/5.6, ¹/₁₀₀ second, 400 ISO

58. OPEN DOOR

GOOD LIGHT AND A SIMPLE BACKGROUND

This is another good example of posing within the light. My students, our model, and I were on our way to an area that I knew had good light and a simple background. When I got to the location, I turned to watch everyone walk through the doors and saw wonderful light.

CREATING THE IMAGE

I had the subject hold the door halfway out and lean around it. This brought his face forward into good light and twisted his core enough to allow the same light to skim across it. No reflectors were needed. The fill came from the length of the light source, as you can see in the diagram and the photograph of the area.

The sun was just out of view beyond the far wall. The light from the sky was more intense from the model's side of the porch than on the east side. This caused the harder contrast between shadow and highlight, which was good in this case.

"By changing the relationship between the reflective glass door and the open sky, the reflection was greatly reduced."

FIGHTING REFLECTIONS

When I set up this image, there was a big reflection in the glass. No matter where I moved, it was there. It dawned on me to have him open the door more. By changing the relationship between the reflective glass door and the open sky, the reflection was greatly reduced. In this case, the light didn't really change for the subject's face, and the background remained the same. I pressed the shutter release and recorded the image.

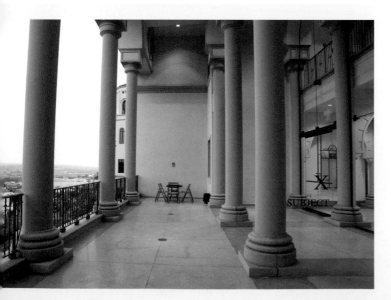

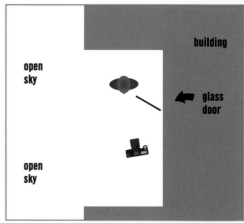

Canon EOS 5D Mark III • Canon EF 70–200mm f/2.8L IS USM lens at 110mm • f/5.6, ¹/₁₀₀ second, ISO 400

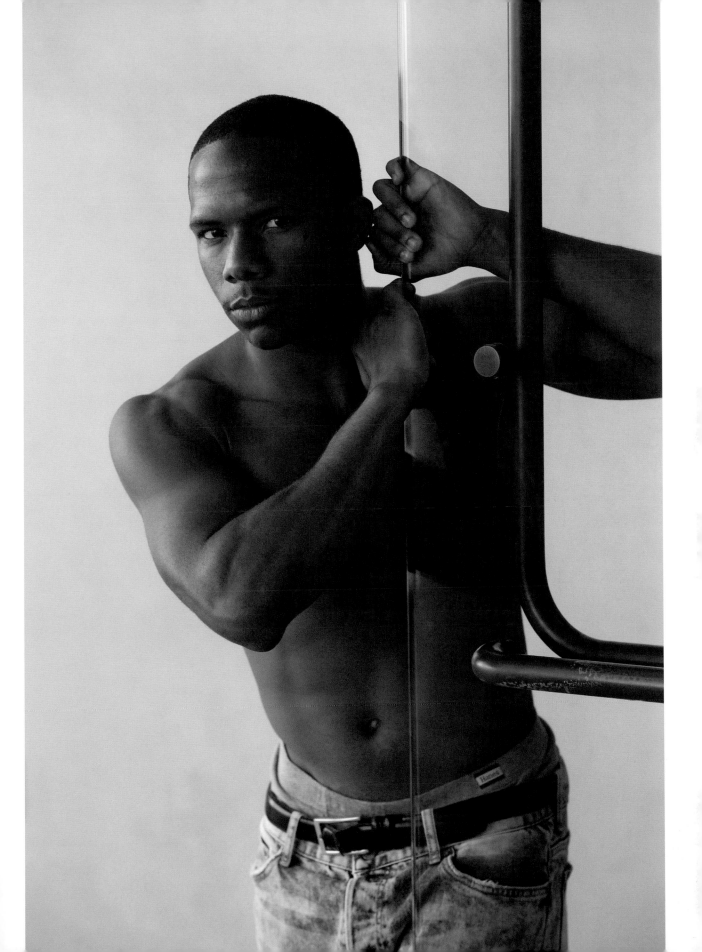

59. PIECES OF ME

The joy of photographing people is getting to know their stories. Listen to your subjects and learn who they are, then use everything you know about portraiture to tell others their story.

THE RIGHT SPACE

This talented teen came to my studio. While listening to him, I realized my studio was not the best place to tell his story. We needed to be in the art room, so that's where we headed. Luckily, there were large windows in the room. The bottom panes were 7 feet tall. Above them were more panes angled in, giving more height and reach into the room. The room felt like an old north light studio—it was perfect!

The artist told me about his work, and I chose two projects to play with. The old TV was the first. As shown in the diagram below, I chose a split light pattern. I positioned the camera in a triangle pattern as I would to create a Rembrandt light pattern. However, I didn't have the subject turn his head fully into the light to achieve the triangle of light. I stopped him when I saw the split light. Now, the artwork was evenly lit and he had good shape. Yes, I wanted to show his talent, but he was to be the focus of the image.

I used a reflector for an accent light.

In another part of the room there was a corkboard where we could hang the other project—a large art piece that needed space. The challenge was the falloff of the light. Look at the "raw" image (facing page, top). See the difference in density from the top to the bottom? Notice that the teen's face is right on that falloff. If he were to take a step to his left, his face would be out of the light. The accent reflector was tipped way back to catch the light near the floor. The accent on his face came from below. You can see it on his face and body, but not the top of his shoulder or his hair. This is the limit in this room for using natural light for portrait work.

The light covered the artist's head in the TV image but didn't quite reach it in *Pieces of Me* (facing page); therefore, his hair is darker in the second image. In postproduction, I burned in the bottom of the second image to match the top, extended the corkboard, and added a frame.

KNOW YOUR LIMITS

Know the distance you can be from your window and still have good light. My windows were only 7 feet tall in my first studio. It was fine for one person or a few if they were seated lower to the ground, but if a subject got more than 10 feet away, they were out of the light.

artwork

high school
art room

east light
window

accent
reflector

Canon EOS 5D Mark II • Canon EF 70–200mm f/2.8L IS USM lens at 90mm • f/7.1, $^1/_{40}$ second, 1600 ISO

artwork

accent reflector

high school art room

Canon EOS 5D Mark II • Canon EF 70–200mm f/2.8L IS USM lens at 90mm • f/7.1, $^1/_{40}$ second, 1600 ISO

60. GETTING FANCY

Even the fanciest images need a good basic foundation. This rings true in this case. Yes, the postproduction work took me out of my comfort zone, but I needed something new to draw attention to me as an artist. I wanted to take what I was already doing and add to it. Applying the brushes and techniques I learned from studying Woody Walters' work was the answer. These days, I think of what the finished work could be—I look beyond what I see through the camera. The finished image may contain several portraits, and there may be other elements involved. Each image in a composite must be able to stand alone. Start with the good portrait techniques that you learned in this book, then take your work to a new level with postproduction painting.

A GREAT RESOURCE

Detailing the techniques that I used to create the final image is beyond the scope of this book. If you are interested, look up Woody Walters at www.woodywaltersdigitalphotocandy.com. You will find all kinds of new toys for your toolbox.

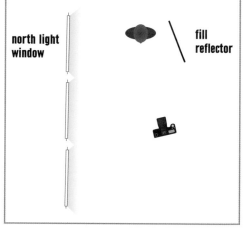

Image 1 (top left). Canon EOS 5D Mark II • Canon EF 70–200mm f/2.8L IS USM lens at 70mm • f/5.6, ¹/₄₀₀ second, 2500 ISO

Image 2 (bottom left). Canon EOS 5D Mark II • Canon EF 70–200mm f/2.8L IS USM lens at 95mm • f/7.1, ¹/₅₀ second, 400 ISO

CONCLUSION

I'm sure, after reading this book, you have learned that there is a great deal to learn about portraiture. Many things you probably already knew. Hopefully I sparked ideas to use old knowledge in new ways. I also believe that you will start looking for quality light areas and good background combinations. You will pose people within the light to form appealing patterns of light in all locations you work. You will anticipate an activity so that you can position yourself in a good relationship to the light and the background and will be able to precisely determine where the subject will be posed in relation to both so that the final image is powerful, without excuses. You will, with practice, become comfortable with finding and using natural light when photographing any subject. Use the concepts you have learned in these pages, and have a great time playing in the light!

INDEX